FEARLESS
PHOTOGRAPHER
FILM IN THE
DIGITAL ERA

Joseph Salvatore Prezioso

with Ingrid Nelson

Course Technology PTR

A part of Cengage Learning

COURSE TECHNOLOGY
CENGAGE Learning·

Australia, Brazil, Japan, Korea, Mexico, Singapore, Spain, United Kingdom, United States

COURSE TECHNOLOGY
CENGAGE Learning·

Fearless Photographer:
Film in the Digital Era
Joseph Salvatore Prezioso
with Ingrid Nelson

Publisher and General Manager,
Course Technology PTR:
Stacy L. Hiquet

Associate Director of Marketing:
Sarah Panella

Manager of Editorial Services:
Heather Talbot

Marketing Manager:
Mark Hughes

Acquisitions Editor:
Dan Gasparino

Development Editor:
Cathleen D. Small

Project Editor/Copy Editor:
Cathleen D. Small

Technical Reviewer:
Donna Poehner

Interior Layout:
Jill Flores

Cover Designer:
Mike Tanamachi

Indexer:
Larry Sweazy

Proofreader:
Sam Garvey

For product information and technology assistance, contact us at
Cengage Learning Customer & Sales Support, 1-800-354-9706

For permission to use material from this text or product, submit all requests online at **cengage.com/permissions**. Further permissions questions can be e-mailed to **permissionrequest@cengage.com**.

All trademarks are the property of their respective owners.

All images © Cengage Learning unless otherwise noted.

Library of Congress Control Number: 2011942307

ISBN-13: 978-1-4354-6091-1

ISBN-10: 1-4354-6091-X

Course Technology, a part of Cengage Learning
20 Channel Center Street
Boston, MA 02210
USA

Cengage Learning is a leading provider of customized learning solutions with office locations around the globe, including Singapore, the United Kingdom, Australia, Mexico, Brazil, and Japan. Locate your local office at: **international.cengage.com/region**.

Cengage Learning products are represented in Canada by Nelson Education, Ltd.

For your lifelong learning solutions, visit **courseptr.com**.

Visit our corporate Web site at **cengage.com**.

Printed in the United States of America
1 2 3 4 5 6 7 13 12 11

This book is dedicated to my godchildren:
Salvatore Prezioso and Joseph Ciampi

Acknowledgments

I would like to thank:

- KEH
- The Finer Image Photo Lab
- Barry S. Kaplan
- Richard Photo Lab
- www.ECN-2.com
- North Coast Photographic Services
- The Brothers Wright
- Scott Sheppard
- Kodak
- Fuji
- All those darkroom photo workers who I have never met

About the Authors

Joseph Salvatore Prezioso is not your ordinary photographer. Starting out at the age of 16 as a stringer for a local chain of newspapers, he learned to shoot on the streets next to some of Boston's best *Globe* and AP photographers of the day. He was there before digital took over and learned to shoot on film before switching to digital.

Today, Joseph has switched back to film after many years of shooting digital. He is a successful wedding photographer, shooting weddings entirely on film. His first book, *Fearless Photographer: Weddings*, has been loved my many and disliked by few. Joseph knows that how he shoots is not for everyone, but he hopes to make a difference so that whether or not you agree with him, you always learn something. His goal in life is to push boundaries and stay creative.

Ingrid Nelson is a professional photographer living in the foothills of Northern California. The daughter of two painters, she fell into artistic expression quite easily and started taking her first photos around the age of 10. She started shooting professionally in 2002, when she created her business, Myrtle & Marjoram. Since then, many weddings and moments later, she finds herself still inspired by the lens and the world around her. Oh, and she still shoots film.

Contents

Introduction

Many years ago, as a kid, I picked up a camera and started taking photos on family vacations, shooting on everything from a Polaroid to a 110 camera to an early shoulder-mount VHS video camera. I still have the Polaroids and the 110 shots, but I have no idea where any of those VHS tapes ended up—and whether they would even play if I could find a VHS player.

What does that have to do with this book? Well, everything. I have the negatives and the prints from all those photos that I took so long ago. If I had just stored them on a VHS tape, they would be lost. That's how I sometimes feel about film versus digital—the digital images can often be lost if they're simply stored on memory cards that get misplaced along the way.

This book will teach you how to take killer photos with film—images that you'll have forever, and that won't simply be lost in a pile of old memory cards. *Fearless Photographer: Film in the Digital Era* will open your eyes and your creative edge to a world not restricted to computer processing power or megapixels. I want you to finish this book a better photographer—make that a *great* photographer. Through assignments and trial and error, you will learn to photograph using film. So what are you waiting for? Let's get started!

Welcome
to Film Land

1

Some 15 years ago, I picked up my first real camera and started shooting. I was a teenager in middle school. It was a Canonet 28, a cool camera from the 1970s that was mass-produced as a quick and easy camera to use. It had a built in meter, but more importantly, it was fully manual. For the first time, I could focus on what I wanted and not have the camera choose for me—as is the case with point-and-shoots. I took this camera everywhere I went, and soon I wanted more.

Why Film?

I moved up to a Canon Rebel G after seeing my high school instructors use it on field trips. Moving up from a 1970s rangefinder camera to a modern autofocus SLR was a huge jump for me. Soon I was shooting film by the caseload. I would go to Costco or Sam's Club and buy the film in the 10- and 20-packs they sold, shoot it, bring it back, and get prints made. At that time, I was shooting almost 10 rolls per week—learning, trying new things, and always looking at my prints to see what I was doing wrong and what I was doing right.

SLR versus Rangefinder

On an SLR (*Single Lens Reflex*) camera, when you look through the viewfinder, you see through the lens of the camera, and you see exactly what will be recorded on your negative. This is done through a mirror in the camera that reflects the light coming through the lens to your eye. A rangefinder, on the other hand, doesn't have this mirror. You look through a viewfinder that doesn't reflect exactly what your lens is seeing. The viewfinder usually has bright lines to show you what your lens is seeing and marking to correct for the parallax, or spacing between the viewfinder image and what the lens is really seeing. Rangefinders are generally smaller and lighter than SLR cameras and can be shot handheld at slower shutter speeds, because there is no vibration from the camera's mirror flipping to let light pass to the shutter.

"This was slide film. It blew my mind."

Gradually, I wanted to shoot more and more slide film and less negative film. This way, I could share my work with more people in the form of slideshows. With negative film, I got back negatives, but you couldn't really see the actual image in a negative because it was, well, negative! Slide film, on the other hand, produced a positive image, so people could look right at the frame and see the image. I could mount the frame in a slide case and show it on a projector to a large audience. I was sold.

I joined a local camera club and was soon bombarded weekly with amazing travel images, landscapes, and stories from mostly retired folks who were traveling the world and shooting the amazing things they saw. Seeing the national parks on huge 50-foot screens in total darkness just amazed me. You were there at the parks, among the trees, in the snow. You were there. This was slide film. It blew my mind.

From that point on, I was shooting slide film, buying it in bulk at Costco and Sam's Club, and putting together my portfolio. I must have shot thousands upon thousands of slides, each time trying something new or seeing how I could shoot better. At the time, *National Geographic* was all slide film, and that was a huge inspiration for me. Seeing what photography was all about and getting the image right the first time, in camera, was what I was after. After all, digital correction was not available at the time for the public, just in high-budget movies and magazines. Besides, slide film offered instant gratification. I could just look at my image frame, hold it up to a light or place it on a light box, and see the image. I didn't have to print it to see what the color and contrast looked like. I could see what all my shots looked like right away.

"Slide film offered instant gratification."

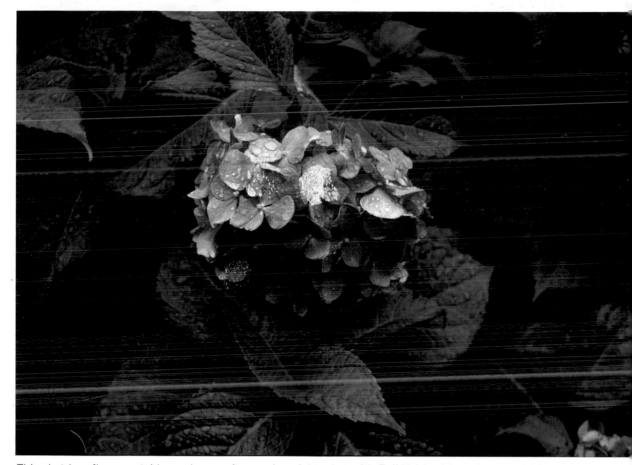

This shot is a flower outside my house after a rainy night, shot with Fuji Velvia. I love the way Velvia captures color and detail. Velvia is an ultra-saturated film; it's high contrast and great for producing vivid images with little to no grain. I wouldn't shoot people with this film, because it could make them a bit orange depending on their skin color, but it's the best for nature!

When I went out to shoot, I didn't generally go to national parks and such. I was in Boston and limited to where my family went on vacation or my school took me. Hence, my slide photos are not national park images—but they're still fun!

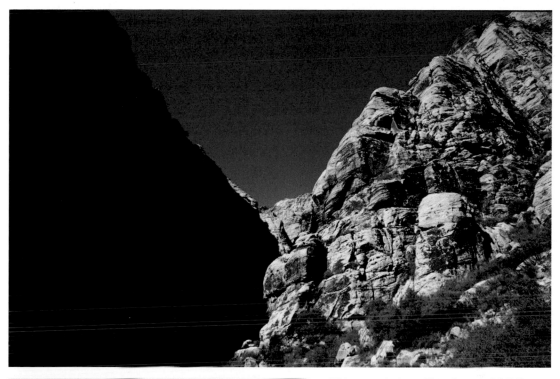

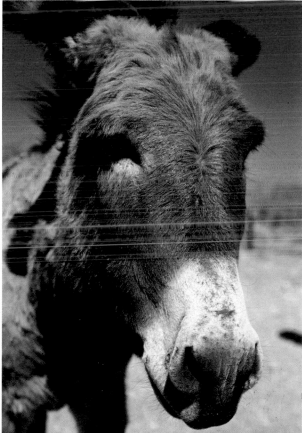

This was shot on Ektachrome 100VS (vivid and saturated). I was hiking around Red Rock Canyon, and I wanted a film that would capture the awesome color and details I was seeing so I could do a slideshow when I got back home. I love the way this film makes the sky so blue—just how it looked with my sunglasses on.

On the same hike in Red Rock Canyon, I encountered some wild burros. Just look at the color and the detail of his hair in the midday sun! Love it.

NOFEAR

Don't be afraid to shoot film. Yes, there's no LCD to see what you just shot, but trust me—you'll live.

Around 1999, I got offered a job shooting for a local newspaper. The newspaper was all about color and required that I shoot color negatives they could process and scan in about an hour. Slide film had to be sent out; the paper didn't have the equipment available for me to shoot assignments on it, so I was back to shooting color negatives. I was given rolls of film and sent out all over. Little League games, murder trials, political debates—I was at them all with a bag full of film. Here, I was first introduced to what has now been coined the *hybrid workflow*. After getting the negatives back from the lab, we would look at them on a light box, the editors would pick what they wanted (even though they couldn't see the real image, they looked for focus and shape), and then the negatives would be scanned to JPEGs on a Nikon CoolScan.

At the time, the newspaper was being digitally designed with QuarkXPress, so they needed digital files to lay out in the paper. At the time, digital cameras cost about $25,000, had about 2-megapixel resolution, and didn't shoot well in low light.

Pro Film versus Consumer Film

Pro films are lower contrast and finer grained but are consistent for a certain time. They need to be refrigerated, and they have an expiration date. Consumer films are generally higher contrast and produce more vivid prints. They don't have to be refrigerated, and they have a longer shelf life. However, if you were to shoot a few rolls of consumer film and compare the images, they all might be a little different, whereas images shot on pro film should look the same.

(Facing page) I was shooting the Charles Regatta on an overcast day. I must've shot 10 rolls or more of men and women racing, but then I saw this man coming down the river by himself. It was my favorite shot of the day. This was shot on Ektachrome 100, low saturation and low contrast. It's not that great in low light, but it's all I had with me that day.

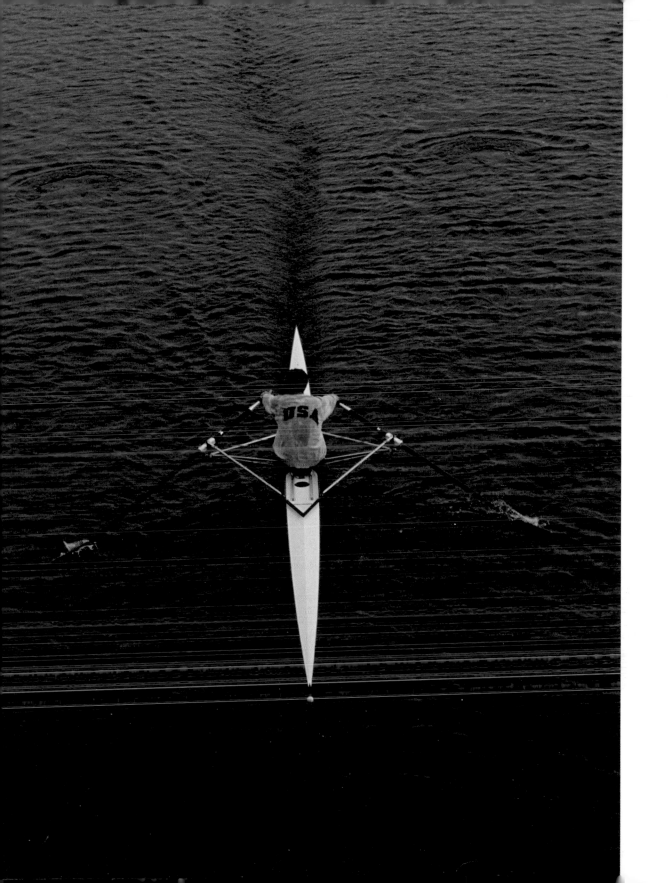

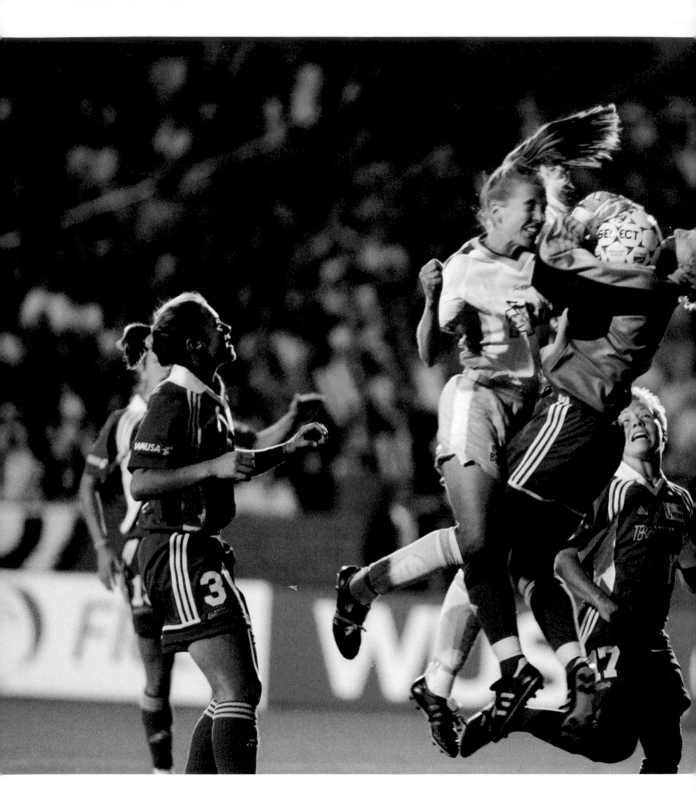

When I was a newspaper shooter, I got to cover many cool events. This image is from the opening games of women's major league soccer, featuring the Boston Breakers. I was sent to cover the event because local kids from the Revere Youth League went to cheer them on, and I got a cool story. This shot was taken with a 300mm lens on my Canon Elan IIe on Fujicolor Press 800 film, at about 1/250 at f/2.8. I clearly remember seeing photographers from the Associated Press shooting on some of the new Kodak hybrid digital cameras (which cost $25,000 at the time), and I wonder where their photos are now—probably on a floppy disk somewhere!

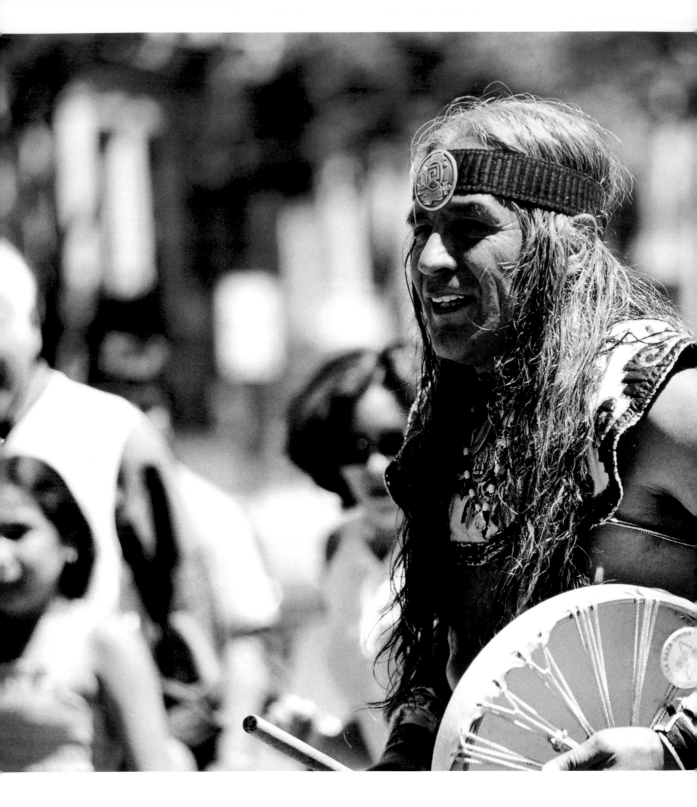

These images from 2001, shot on Kodak Royal Gold 100, were taken on my Canon Elan IIe as well. I was assigned to shoot a Native American festival in one of the town parks. It was noontime and direct light, but the film captures all the details of the image without blowing out any highlight details, and it still retains awesome shadow details. Because it was shot on consumer film, this image has slightly higher contrast then pro film would, but it looks awesome nonetheless.

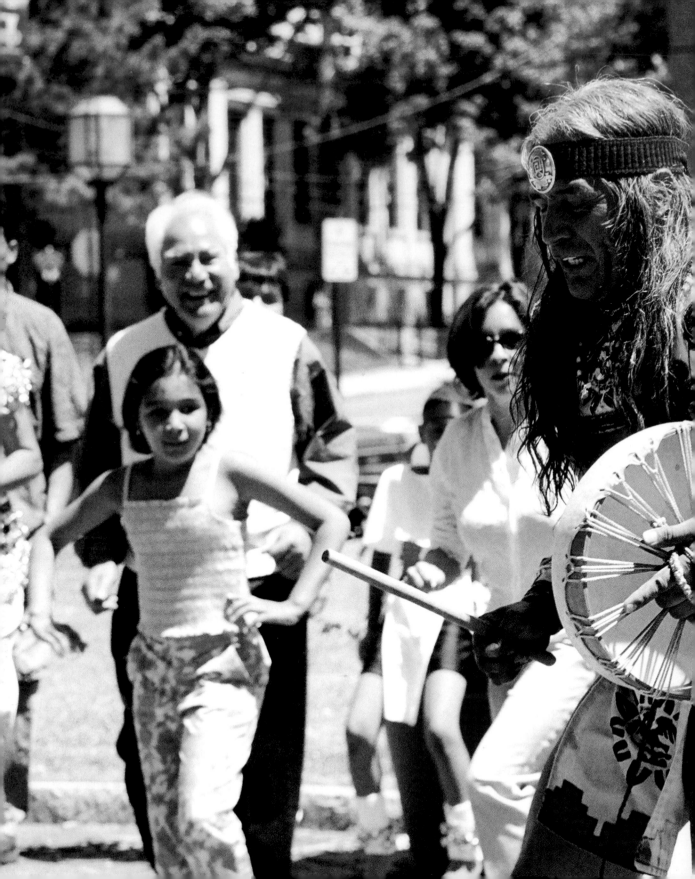

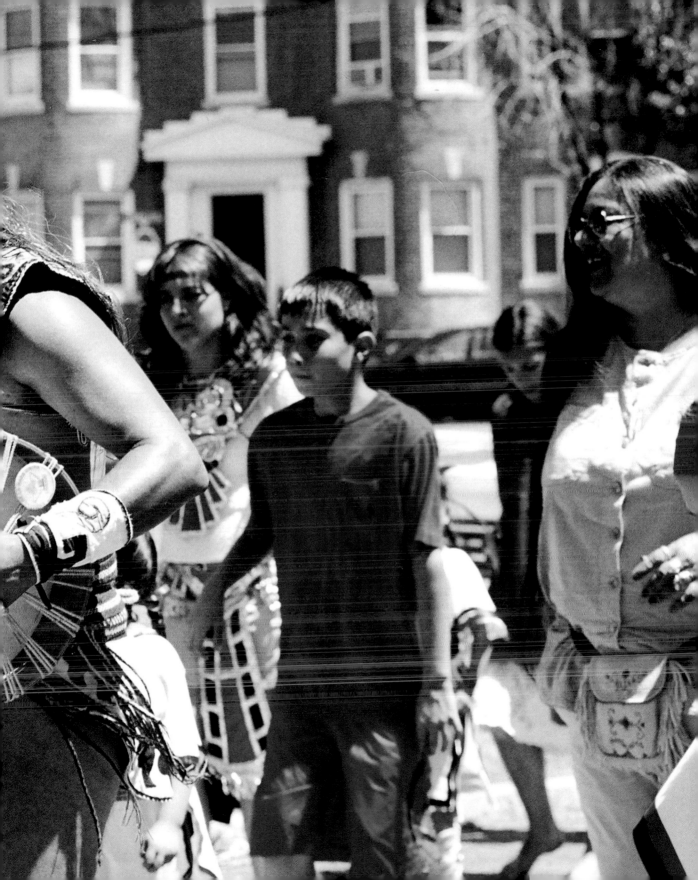

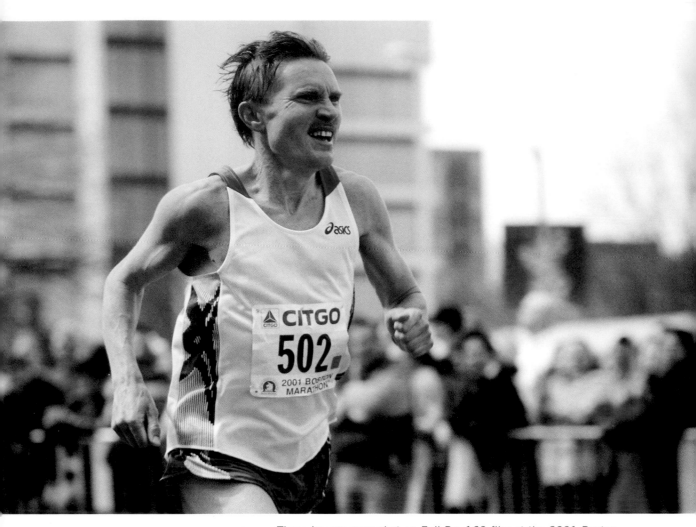

These images were shot on Fuji Pro 160 film at the 2001 Boston Marathon. It was a cloudy day and the light was very flat, which I thought was perfect to show these runners in their best form. I positioned myself near the end of the race, hoping to get images of the runners in their most tired state, yearning for that finish line. I shot these images with my Canon 300mm f/2.8, on my Canon Elan 7. Once again, the film captured great detail in both the subject's shadow and highlight areas. There is great range from shadow area to the direct-sun areas. If I'd shot digital, the highlights would have been blown out, and the color and details would've been lost.

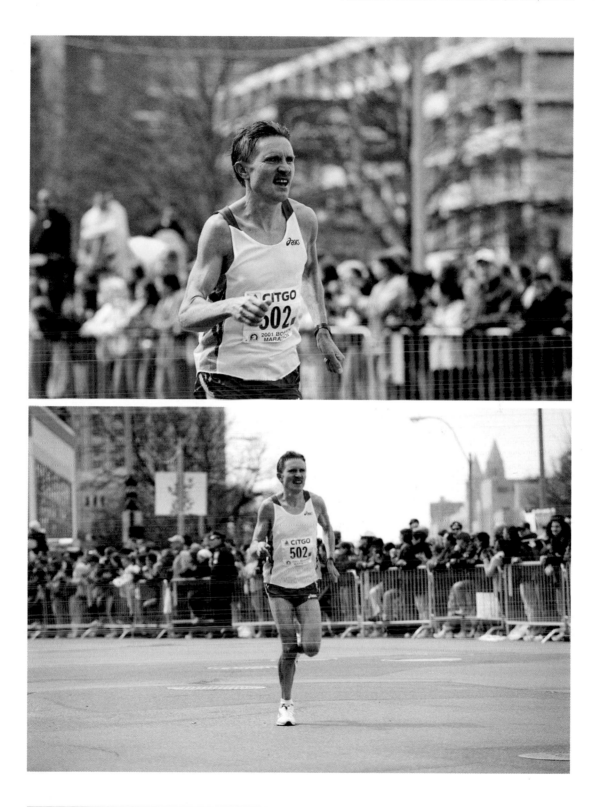

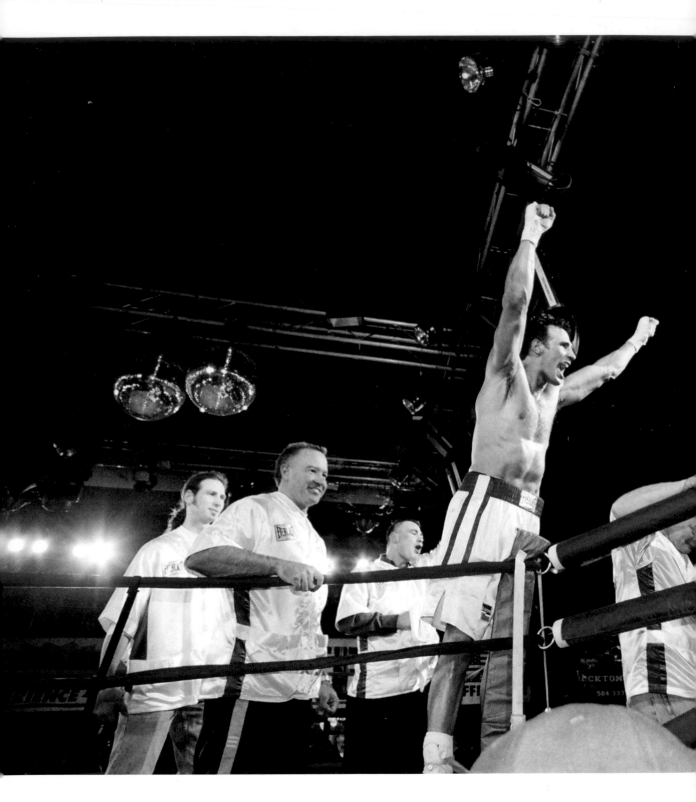

This image was shot on Fujicolor Press 800 in about 2001, when I was assigned to shoot a local boxer fighting. This was a major victory for him, and I shot it with just ambient light. I love how the film captures good contrast and color throughout the image, even under television lights. I used a Tokina 20mm–35mm lens at f/2.8.

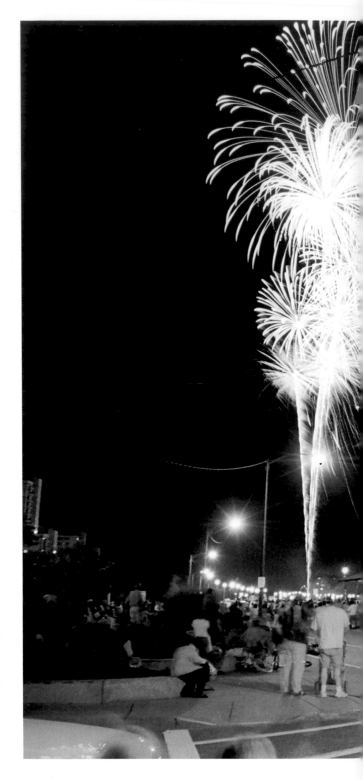

Another example of film's ability to take beautiful images in the harshest light. This was taken during a local fireworks display on Revere Beach. I had my camera on a tripod loaded with 400 speed film. I just set the camera to bulb mode and f/16 and let the shutter stay open while the fireworks exploded overhead. The film recorded the explosions and the people in the foreground without loss of details. The ground is cast in green due to the city lights, which must have been some type of fluorescent bulbs.

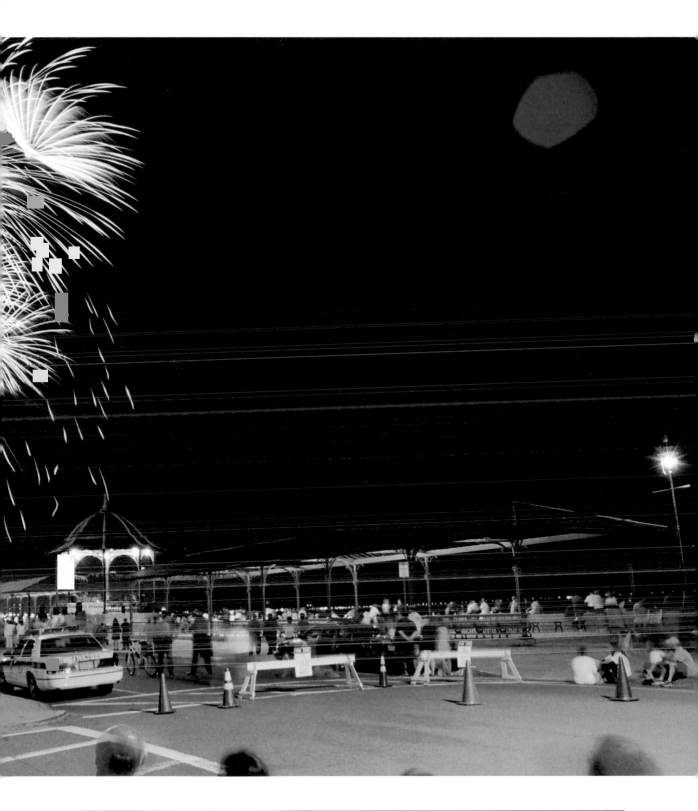

"In essence, my hours tripled for the same pay."

Film was the only option until about 2003, when Canon and Nikon both released dSLR pro bodies that cost less than $5,000. The newspaper jumped at this. No more lab bills! The newspaper I worked for (and most around the country) bought (or had their photographers buy) digital bodies and then sent them out in the field. After that, we were required to shoot more and spend hours on the computer sorting and color-correcting the images to the newspaper specs. A once simple job of shooting and dropping off the negatives now became a nightmare. I had to sit at a laptop for hours and edit and adjust images. At the time, digital cameras still didn't do well in low light or with flash—the images just looked bad, grainy and muddy. We started using Photoshop actions and noise-removal applications to make the images better, so that the paper could save money by not paying for film or a lab bill. In essence, my hours tripled for the same pay.

Eventually I got laid off, as did many photographers around the country. Digital online news was killing the newspaper industry. I actually didn't care at that point; I had lost my love for the industry long before. But that's another story....

At that point, I was 100-percent digital and shooting weddings to pay my bills. I sold all my film gear and was now at the mercy of Photoshop. It's lucky that I love weddings, because from 2004 to 2009, that's all I did. All on Canon digital cameras. How many hours of my life did I spend editing all those Raw images? Each wedding had me at my computer for about 10 hours, editing away in Aperture. And every time I got a new camera, I had to upgrade my computer to handle the new Raw format or the larger file size. It was a vicious cycle. I longed for the days of shooting and just getting prints back, but I nearly forgot what it was like to be a film shooter and just accepted things for what they were.

That all changed in early 2009, when people started talking about film again. I heard about this thing called Lomography in New York City and a new film from Kodak called Ektar 100. Many people were whispering about film; it was an underground movement, and members didn't want others to know that they were starting to shoot it. Well, okay, that's a bit of an overstatement—but it felt that clandestine!

"I longed for the days of shooting and just getting prints back..."

I picked up a few rolls of the Ektar and fell in love instantly. I started shooting it for myself. I even picked up a Russian panoramic camera from the Lomography store in New York City and started shooting my trips all on film. I would shoot, drop off the film at the lab, and get high-resolution scans of my images back on a disc with the negatives, and only sometimes prints. I was blown away when I opened the files. The color, the look, no Photoshop needed—these images were good to go.

Photo from trips shot on my Horizon Perfekt.

I started bringing my film cameras to weddings. I wanted to see how weddings would look on film, because at that point I had only professionally shot weddings on digital. I shot film at weddings years before, but that was long before digital, so I needed to compare my results.

I was blown away. Every frame was amazing. Black-and-white, color—it made no difference. I was getting the shot, the image was captured, and the exposures were perfect. With digital I had to shoot like slide film—there was no room for error. You blow the highlights, and you're done—they're gone. With negative film, the highlights were there, as were the shadow details. The negative is like a super Raw format—it captures the light and records it. There are no compression algorithms or loss of data, just a chemical recording of what you captured. It's analog, and I was sold. I slowly traded in my digital gear, and by the summer of 2010, I was shooting 100 percent film. I would shoot, drop off the film at the lab, and get back awesome scans. All I had to do was sort them and put them online. I had more time to blog and market myself—and to live my life.

"I was blown away. Every frame was amazing."

These tests are by the Brothers Wright studio in LA. ©Brothers Wright. The image shows highlights and shadows on digital (Nikon D300) versus film (Fuji 645 with Fuji Reala 100 film). The first test (this page) shows normal exposure, and the second and third images (next page) show two stops over and two stops under, respectively. Notice the sky and the loss of the highlight detail in the digital images, whereas with film the sky, highlights, and subject are all exposed nicely. Thank you to the Brothers Wright for these images.

"Film reopened my eyes and allowed me the freedom to be more creative in what I was doing."

I also wasn't limited to just shooting the 35mm format size or restricted to just Canon or Nikon. I now had an entire world of cameras and formats open to me. Film reopened my eyes and allowed me the freedom to be more creative in what I was doing.

NOFEAR

Don't be afraid to use a camera you've never heard of or are unfamiliar with. You don't need to stick with Nikon or Canon. There are many film cameras from the past 50+ years that rock!

Since then, Kodak has released new films, which I will cover in depth in later chapters, that have given film a new life and have pretty much blown away what 90 percent of digital cameras (and Photoshop) can do. The dynamic range of film—its ability to be properly exposed and let you capture an image even if your exposure is way off—is what makes it special to me.

I recently shot this image at 1/60 and f/2.8 on ISO 160 film. The subject was in the shade under a deck; behind him was the beach in full sunlight, which was about 1/100 at f/16. When I went to scan the negative, I realized that all the detail was there—the beach to the subject at f/2.8. That's five stops. Try that on your digital camera!

Ingrid's Turn

I'd like to add another viewpoint to the "Why film?" question. I, too, have been shooting film for a very long time. I got my first film camera when I was 10 years old. It was a little red point-and-shoot. I have no idea who made it or what became of it, but I do have memories of taking photos with it, sending the film away to be developed, and waiting impatiently for it to come back in print form. And *that* is the main reason why I still shoot film today. Yes, I agree with all the technical and time-saving aspects that Joe pointed out earlier, but for me, the *magic* of film will always remain in that anticipatory aspect of not knowing exactly what you've got until the images are developed. The whole of photography for me is in the *waiting*. You wait for moments to unfold before your eyes, the film waits for light to hit it through shutter and aperture, and the exposed film waits for chemicals to bring it to life. None of that chemistry happens with pixels. Anticipation and mystery become part of the art form itself.

Some may argue that as a professional photographer, you should want to be 100 percent sure for your clients, but I have to say that shooting film actually strengthens my abilities to see what is happening *before me* and not on a little LCD screen. Your shooting approach changes when you shoot film. There is no checking on the back of your camera; there is only looking at your scene and your subjects through your viewfinder. Over the years, this has made me very attuned to the subtle moments and the quickness of passing time. It encourages you to slow down to capture something that happens very quickly. It forces you to become a better observer.

Event photographers are often hired to record people's personal histories. I like how film has a permanence of taking these moments and freezing them onto a strip of film. I have seen many digital photographers delete files moments after they've taken them, either to free up space or because they saw that the image wasn't perfect. This actually changes your perception of history. With film, you tend to get the perfect moments alongside a set of outtakes. In 20 years or so, what will we look back to? A history with no closed eyes, no human errors? I love how film holds onto that instant of truth with a little more tenacity. Yes, all photography is subject to interpretation and perception, but film seems to hold a bit more authenticity in the long run. (There will be an assignment at the end of this book that urges you to shoot one roll of film over the course of a day—print that contact sheet, and you'll see what I mean.)

Film also pushes you to be a little more watchful and practiced due to the cost. Unlike a digital shooter, who can basically keep a finger on the shutter button in rapid fire, we film shooters have to capture the moments with a human eye and one click. Each time we press the shutter release, we know there will be a small cost. It makes you care about each individual shot, and if you don't *know* your film, your equipment, and your lighting, your photos won't come out on a consistent basis.

So why film? Use it because it will give you magic and make you a better visual spectator.

Candid moments captured on film.

Digital and Film Differences

"If you like the way film looks as prints, then shoot film."

I'm not a scientist or a numbers guy. I can't tell you scientifically why I believe film is better, but I can offer my viewpoint as a professional photographer.

Digital images are made up of ones and zeros, composed of compression algorithms and computer files. Film is chemical. Does this matter? Perhaps. Pixels, which make up digital images, are square; whereas film grain is kind of round. The round shape of grain is perhaps more organic and pleasing to the eye than the harsh square pixels of digital.

One thing I *do* know is that I have yet to see a digital camera capture the highlight and shadow detail that an image shot on negative can. Yes, with digital you can take multiple shots and align them on a computer (using HDR, or high dynamic range photography), but negatives pretty much get everything on one shot.

For me, a lot of it is workflow and image quality. With digital, I was spending more time editing and backing up images onto multiple hard drives and discs than I was shooting. With film, I shoot the film with the look I want, and then I just have to sort the scans to a story-telling structure when I get them from my lab. I back them up once, knowing that I have physical negatives to turn to if my hard drives should fail. And trust me, they *do* fail. So not only am I getting image quality that I believe is more pleasing to the eye, I am also getting to spend more time living my life instead of messing around in Photoshop, applying effects to make my shots look like film. After all, why would I want to do that? If you like the way film looks as prints, then shoot film.

The other big reasons why I love film are exposure and flash tolerance. With digital, it's like shooting slide film: Up or down even a third of a stop, and there is a noticeable difference in your image. Yes, you could correct in Raw digital images in your editing software, but that takes time. With film, I can shoot a 400-speed film anywhere from 200 to 1600 and process it normally, and I get great shots. I don't have to worry about whether my exposure is dead on; I can just shoot. Of course, I always try to make sure it's dead on, but sometimes life moves pretty quickly or lighting changes, and I don't have time to change things and just shoot. With flash I can also feel safer, knowing that even if I overexpose with it, my subjects won't be blown out. In effect, film loves light—it loves more light than it needs.

These images were taken with 400-speed Kodak Portra 400 film, rated at 1600, in camera and processed normally. They were not push-processed. (We'll discuss push processing later in this book.) In essence, I underexposed each frame by two full stops—three in some.

Case in point: I was in a portrait room, shooting some family members during a winter wedding. I had my camera set to about 1/30 at f/1.4 with ISO 800 film loaded. The room also contained my studio lighting setup that I had just used to shoot some group shots at f/8 with ISO 100 film. What I didn't realize is that the studio strobes were set to slave mode (to fire when they see a flash), so when I fired off shots of people in the room with my on-camera flash, with the ISO 800 film and my lens wide open, I had no idea I was setting off the studio strobes! You might think that these shots would've been ruined, but they weren't. They came out great, as you can see here!

The image on the top shows the film exposed to only my on-camera flash, set to bounce, and the ambient exposure. The image on the bottom is with the studio strobes going off by accident and overexposing the negative—and giving a much better image.

With film, I'm also set free to shoot larger formats than 35mm frames, so I can shoot higher-speed films on larger negatives and get images that look like they were shot at lower ISO settings, with even less grain and more details. Whether you're shooting film or digital, the larger the capture area size, the more detail and light you're utilizing to record your image. I can easily shoot medium format at a wedding and get highly detailed images that burst with color and detail, even at high ISOs.

In the following chapters, I will talk all about everything from choosing cameras and films, to processing and special processing, to getting your images scanned, and I'll provide you with a number of assignments that should open your eyes, get you into the film workflow, and improve your photography skills.

Images were shot on Ilford 3200, a high-speed BW film, in a dark reception hall.

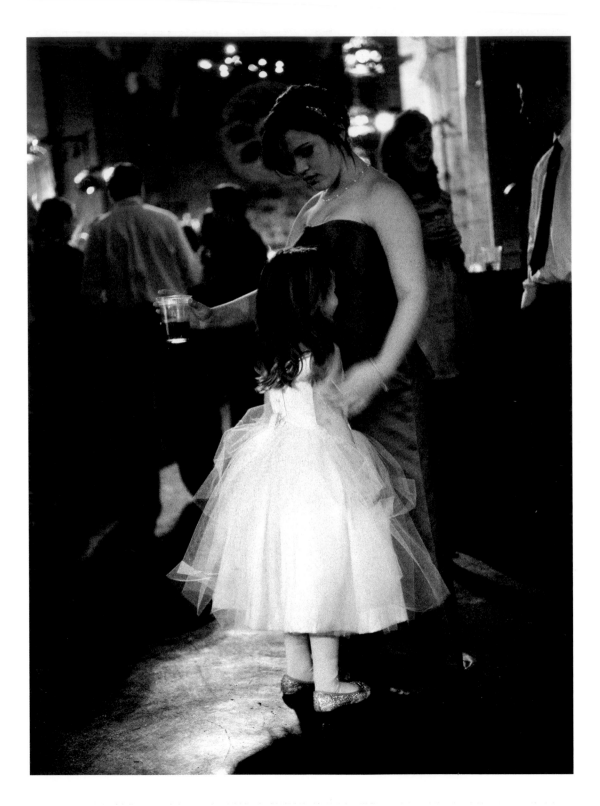

Ingrid's Turn

For me, the differences between film and digital are about the artistic approach and process more than about the technical aspects. Shooting film forces you to trust in the unknown a bit more. When you shoot in film, there isn't any instant gratification (unless you're shooting with instant Polaroid or Fuji stuff, and that's an entirely different realm). You trust in the moment and trust in what you see when looking through the viewfinder. I've found that the trial-and-error period with film is lengthened over the course of time it takes to shoot, develop, and print. The learning curve with digital is *much* shorter because you can see when you like something or when something doesn't work, and you can alter it immediately. This has definite perks, and I'm not saying that isn't a strong plus for shooting digital. I mean, who really has time for anything these days, let alone *learning*? But something happens to us in the interim, when we step away from the shoot and come back to try again. I think there is growth in the "in between" and reflection. When discovering your craft, you may stumble across your personal style quite by accident or spend months and months experimenting with a certain film, developing, and light combination until you find exactly what you want (if that *ever* happens). I repeat: Waiting for something makes it *more* special.

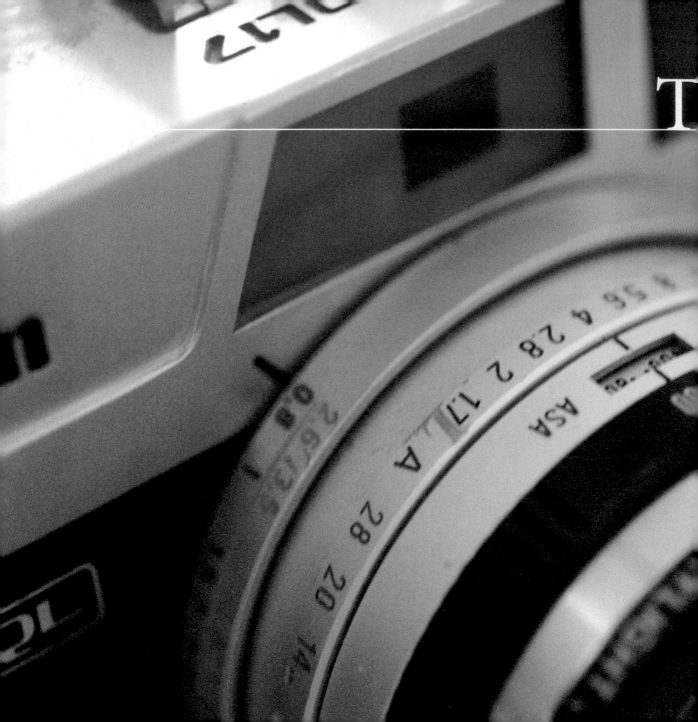

Cameras: Tools of the Trade

2

So now that you're shooting film, your doors are open to literally hundreds (if not more) of types of cameras to shoot with. No longer are you relegated to only a 35mm-based sensor digital SLR, whether it be Canon, Nikon, or one of the other digital SLR makers. Now you're in a world where megapixels are not needed. You can shoot anything from 35mm to 8×10 cameras with the current films available. In the following pages, I will go over some of my favorite cameras and how I use them—and as an added bonus, some other photographers will weigh in on their favorites as well. There are so many cameras that I can't talk about all of them, but I'll touch on cameras that are useful and powerful imaging tools.

All film cameras function primarily the same way that digital cameras do, except instead of a CCD or CMOS sensor, there is a film chamber and film. They both have shutter and aperture control and ISO settings, but some film cameras can function entirely without a power source, such as a lithium ion battery. So, if you're on a long trip and you don't have access to a place to charge your batteries, you can still shoot. Most modern film cameras with matrix/evaluative metering and motor drives will require batteries, but in the film world there are cameras for everything.

Canon EOS

My first SLR camera was a Canon Rebel G that I bought in 1999. It was my entry into the world of EOS, the Canon film system. With a huge selection of lenses, flashes, and cameras, the EOS system is just as powerful as Nikon when it comes to 35mm SLR shooting.

Since 1989, Canon has released many cameras, all autofocus and very reliable.

Canon 1V

This camera is the top of the line of film cameras for Canon. It was the last pro film camera released by Canon before they went all digital. I shot this camera many times, and it never failed me. With 45 autofocus points, a super-fast motor drive, and selective metering patterns from spot to matrix, I never missed a shot.

Canon 1N

Before the 1V there was the 1N—a mighty camera in its own right and very fast. Lighter than the 1V and just a bit smaller, the 1N still has all the same functions. However, instead of the 45-point autofocus, it has 5.

Both the 1N and the 1V run on regular AA batteries and can shoot many rolls before you have to replace them. Both have TTL (*through the lens*) metering for flash, with the 1V having E-TTL (a more advanced version of the metering system). I would recommend either camera to anyone wanting to shoot fast and with a pro-level body. The 1V costs more—maybe even double—but it's not twice as good as the 1N. Both take awesome shots.

"My first SLR camera was a Canon Rebel G that I bought in 1999."

Images taken with my Canon 1V.

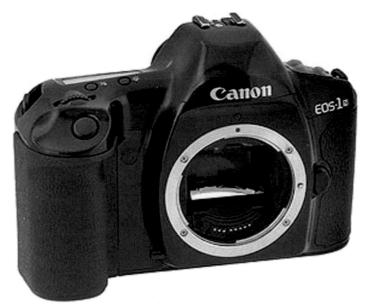

The Canon 1N.

A cheaper way to get into the EOS system is with a non-pro body, such as the Elan II or Elan 7. I think the Elan 7 is a great camera, with insanely fast autofocus and almost every feature that the 1V has, save for the weather-proofing and motor drive. I used the Elan 7 for years as a newspaper photographer and also took it on many international trips. It never failed me.

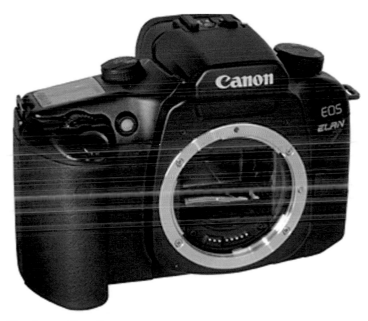

The Canon Elan 7.

"I used the Elan 7 for years as a newspaper photographer and also took it on many international trips. It never failed me."

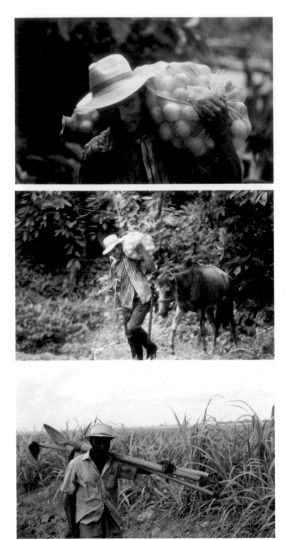

I took these photos with my Elan 7 with a Tokina 80–200mm f/2.8 while in the Dominican Republic. I shot on Kodak slide film. The camera's meter never failed me, and the autofocus let me take these shots from the backseat of a moving Jeep as we drove through a sugarcane plantation. There was no way for me to manually meter and focus everything when we were moving at such a high speed, and the light was so different everywhere that I had to rely on the camera in Shutter Priority mode with the metering set to matrix.

Canon EOS-3

There is also the EOS-3. It's a powerhouse and a pro camera in a small package. The EOS-3 has 45-point autofocus and all the bells and whistles of the 1V. I've never used this camera myself, but many people swear by it. For its price, it's supposed to be a great camera.

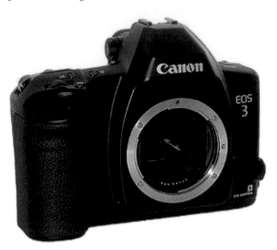

The Canon EOS-3.

Ingrid's Turn

I shoot all my weddings with the EOS-3. It's a great professional camera that is quick and user friendly. I have four bodies, which you can buy used pretty cheaply nowadays.

Canon Lenses

Canon lenses are nothing to ever think twice about. Canon has some of the fastest and sharpest lenses I have ever used. If you read my previous book, *Fearless Photographer: Weddings* (Course Technology PTR, 2010), you know that I primarily shot all my weddings with just two lenses: the 35mm f/1.4 and the 85mm f/1.2. These lenses did everything I needed and allowed me to rock whatever I was shooting. Everything from Canon's prime lenses to their amazing zooms is top-notch.

"Canon has some of the fastest and sharpest lenses I have ever used."

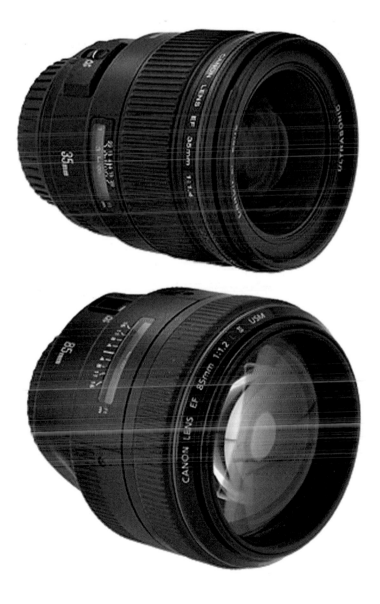

In my mind, these are two of the best lenses ever manufactured for SLR cameras. With blazing autofocus and full-time manual control and sharpness across their aperture spectrum, they are great tools.

The Nikon System

I am a convert. I can't lie. I have used only Canon cameras since the 1990s. But when I went back to film, I switched over to Nikon. I did this for one main reason: I wanted to use a system that would let me shoot film in bulk loads so that I could shoot on motion-picture films. Canon and other manufactures do offer bulk-load cameras, but none of them took modern lenses or had autofocus, so Nikon got my vote.

With Nikon, you can pretty much use any lens on any camera ever made in their system. I could use an older film camera with modern autofocus lenses and interchange them with modern autofocus cameras, such as my F5.

I was sold.

I currently shoot with a Nikon F3 and a Nikon F5. My F3 has the MZ-4 250 bulk pack that lets me shoot rolls of 250 shots instead of the normal 36-exposure rolls. It's a big camera, and I have to load the film cassettes for it in a darkroom. The F3, like every other F camera in the Nikon system, is a pro camera with parts built to last and to be interchanged. I have customized the camera to make it work best for me, with an HP (High Point, for eyeglass-wearers) prism, a non-split prism focus screen, and the MD-4 motor drive. I love shooting on it. It may not have autofocus and all the metering options of my F5, but I've never missed a shot with it.

My F5, on the other hand, is a different breed of camera. Born in the autofocus age, it's the smartest and fastest camera I have ever used. The motor drive can rip through a roll of film in seconds, and its focus tracking is spot-on. It has some of the most advanced matrix metering I have ever used, but what I love most about it is the TTL flash metering with D-type lenses. It's always perfect. Yes, part of this is because film has great latitude, but I know the camera and flash are doing most of the work.

"With Nikon, you can pretty much use any lens on any camera ever made in their system."

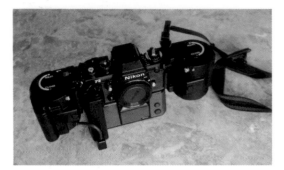

A Nikon F3 with a 250 bulk pack and a Nikon F5.

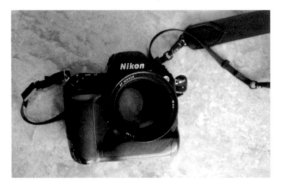

I use these two cameras 90 percent of the time. They aren't necessarily the best or the only Nikon cameras out there, but they're what I use and find to be excellent products.

Other awesome Nikon film cameras include the F2, F4, F6, N90, F100, and FM2—the list goes on and on.

If you're just starting out and want something cheap but awesome, look at the N90. I bought my assistant one for $59 at www.keh.com (the best place to find film gear), and it's a great camera. Quick autofocus, a built-in motor drive, metering modes—it's a pro camera.

More excellent Nikon film cameras.

At a recent camera tradeshow, I was able to play with a Nikon FE. It's a small, light, fast manual-focus camera. It is now on my list to get. This camera was made to carry with you and shoot. My 85mm lens may be bigger than it, but the camera is still 35mm and accurate.

Flashes

Because you're shooting with film cameras, you won't need the new super-expensive Speedlights that fire a pre-flash to determine exposure for digital images. You can use almost any flash Nikon has ever made on pretty much any film body. (The exception is the newest flashes that are digital only.) I use the SB-80DX flash because it is small and powerful and offers manual control and wireless flash control. I can have my on-camera flash control my off-camera flash, which I can set up where I need it.

Lenses

With Nikon, I can use almost any lens ever made for Nikon—film or digital era, autofocus or manual focus. The lens mounts are universal. The only lenses that can't be used on some of the bodies are the newer, more cheaply made G lenses. These lenses don't have an aperture ring, so they can't be used on bodies that don't have digital aperture control, such as on the F5, F100, and newer autofocus bodies. But it's really not a problem, because there are more non-G lenses than there are G lenses.

My favorite Nikon lens is the 85mm f/1.4. It may not be as fast as the Canon 85mm f/1.2 in terms of aperture speed, but it blows the Canon out of the water in terms of autofocus. When I'm shooting in low light and shooting moving subjects, the autofocus counts.

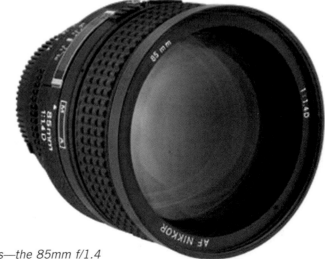

My favorite Nikon lens—the 85mm f/1.4

645 and 6×7

My camera bag contains many cameras, usually one of which is a medium-format camera, such as the Pentax 645 or 6×7. Medium format offers a much larger negative than standard 35mm. The image size of a normal 35mm image is 24×36mm, whereas 645 is 56×42mm and 6×7 is 56×72mm—that's more than double the image size. So what does that mean? It means that more image detail is being recorded, along with less grain and a shallower depth of field. Think of it this way: If you took a 35mm image on ISO 400 film and had the same shot with the same film taken on 645, and then you printed both images to an 8×10, the image taken with the 645 would be sharper and would have less grain.

By the same token, with a larger film plane, you will have shallower depth of field to that of the same aperture, lens, and distance to subject on 35mm. So, if you had an 80mm lens at f/2.8 on a 35mm body, and next to it you had a 645 camera with an 80mm lens at f/2.8, the depth of field would be greater in the 35mm frame than in the 645 frame.

The area of viewing is also about 50 percent compared to a 35mm lens, meaning an 80mm 645 lens gives you about the same view as a 45mm lens on a 35mm camera.

There are many, many 645 cameras, ranging from top-of-the-line autofocus bodies, such as the Contax 645 series, to more stealthy and smaller rangefinder models (with no mirror box, so they are smaller and lighter than SLR bodies, such as the Pentax or Contax 645), such as the Mamiya 6 and 7. These cameras take incredible images that you can blow up to billboard-size prints if needed.

I haven't had the chance to use as many 645 and 6×7 cameras as I would like; to be honest, they cost a lot! I would love to own the Mamiya 7—it's super-light and has manual focus with great metering and quick action. I've had the chance to use it at tradeshows, and it's just a perfect lightweight, high-quality camera.

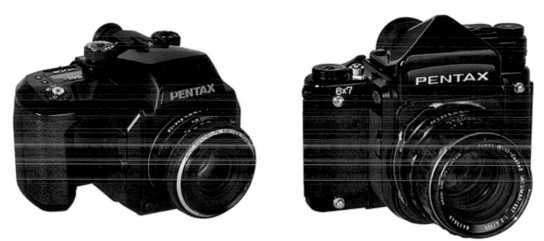

The Pentax 6×7 and Pentax 645.

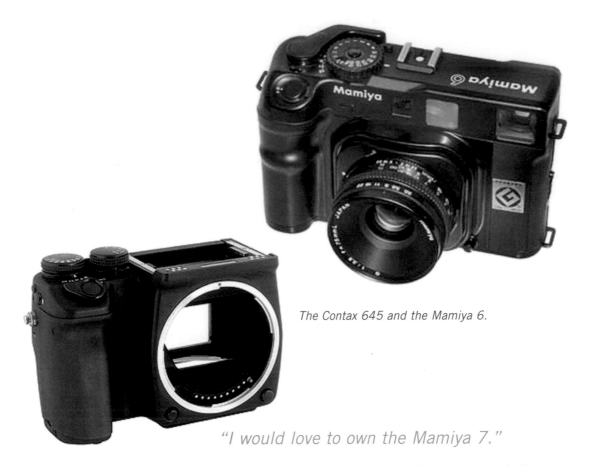

The Contax 645 and the Mamiya 6.

"I would love to own the Mamiya 7."

The Mamiya 6 and 7 are both super-light rangefinders. I've been dying to own one for many years, but I ended up in the Pentax system. The Mamiya system is fast, light, and very customizable. The camera fits well in your hand, and because it's a rangefinder, there is no mirror slap. The meters on the both cameras are accurate as well. I personally still like to meter with my handheld Sekonic, but with a little time I'm sure I could learn the ways these cameras meter and mold it to my style.

There are many more medium-format cameras available—too many to talk about in this book. Just take a look online, and you'll find the one that works best for you. The ones I have just written about are some of my favorites.

NOFEAR

Just shoot. Don't be afraid.

Leica

To some, there is only one real camera: the Leica. Strong, well-built, fast, and small, it's one of the most sought-after and dreamed-about cameras for many photographers. It's also very expensive. With some of the fastest lenses ever made, such as the 50mm f/0.95 lens (which runs $10,000), it's a true professional camera system. With rangefinder focusing and bodies with TTL and non-TTL metering, there's pretty much a camera for everyone. I'm more of an SLR type of guy, and I never really got into the Leica system (plus, I love big cameras), but the Leica system—from the M4 to the M7—has truly awesome cameras. These cameras don't need batteries or power of any kind (unless you want to power the meter in the newer models) and will keep working no matter how far away the next battery store is.

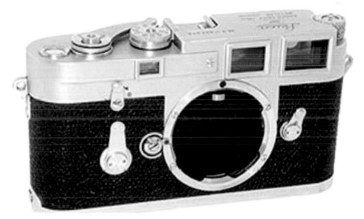

"To some, there is only one real camera: the Leica."

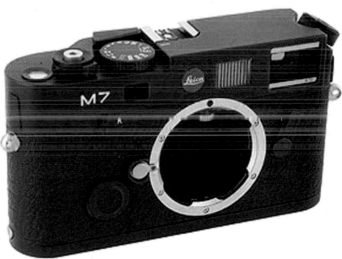

Leica makes excellent cameras.

The XPan

This Hasselblad is one of my personal favorite cameras. I drooled about owning one before I got it. The Xpan is a unique rangefinder camera. It allows you to take panoramic images across the space of two normal 35mm frames, so you get double the detail. On a 36-exposure roll, you would get 18 shots. I love the perfect straight framing of this lens and the cinematic look I achieve with it—very much like the super widescreen movies you see with a 2:35:1 ratio, a very wide view. It also allows you to switch back to standard 35mm frames with the flip of a switch.

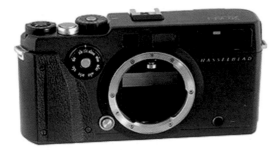

The Xpan is a rangefinder camera.

The camera focus is not as fast as most rangefinders and not the best for action. I've tracked subjects with it, but it takes some practice. The XPan runs on batteries and needs them to power the motor drive, as there is no manual advance. To be honest, I wish there was—this camera sucks batteries dry after a few rolls. I always have this camera or my Lomo swing-lens camera with me. There is no digital camera with a panoramic-sized sensor that is equal to the frame size of the XPan. There are cameras that stich images together as you pan, and there is software that lets you stich photos together, but none can capture a panoramic in one single shutter click

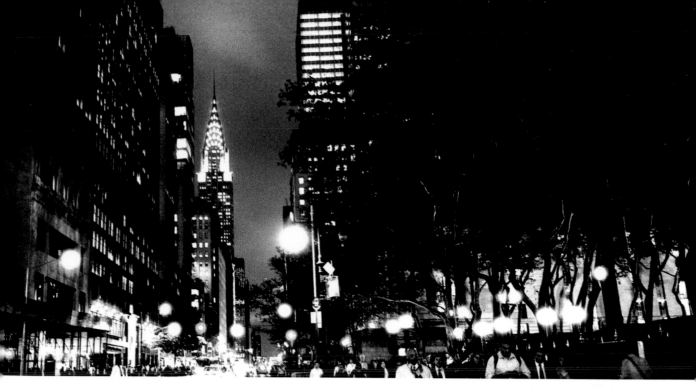

Images of New York City taken with my XPan.

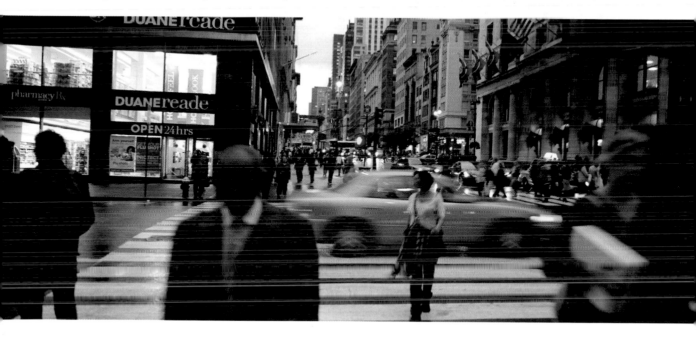

The Horizon Perfekt

The Horizon Perfekt is a fun and truly amazing panoramic camera from the USSR. Made in Kiev, Ukraine, this Soviet-era camera is now sold in the United States by Lomography. This is one of the most wicked cameras ever made. It takes no batteries, doesn't meter, and is all manually controlled.

What makes this 35mm camera even more amazing is how it takes panoramic images. It has a swing lens. The lens rotates in a splash of a second from left to right, exposing a frame and a half-size image, yielding about 23 to 24 frames on a 36-exposure roll. The swing lens creates a unique, almost curved world because of the lens' rotation. If you're not holding the camera level, you'll get a very fisheye look to your images. I love this camera and try *not* to hold it level—otherwise, I'd just shoot with my XPan all the time. I love the unique look that I get from the Perfekt.

Images shot with my Horizon Perfekt.

The camera doesn't really look like a camera, so it's great for street shots or for places where you don't want to be seen with a camera and you want to be more discreet. With its 28mm f/2.8 lens, you can easily take shots from your hip and just fire it off and capture unsuspecting life around you. It's great for city shooting.

"I love the unique look that I get from the Perfekt."

Lomography

Lomography is a society and a company. They sell film cameras of all shapes and sizes, and they have a site where users can share their work and talk tips and ideas. It's a great place to look for some cool cameras and to learn about doing some neat camera tricks.

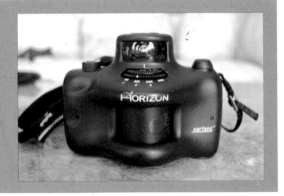

The Horizon Perfekt.

Spinner 360

The Spinner 360 is a new addition to my camera bag—and to the camera world, for that matter. Released in the fall of 2010 by Lomography, this camera is something that no one else has. It features 360-degree image capture. With two settings—f/11 and f/16—and a ripcord, there are no settings or focus controls to play with. You simply hold out the camera, pull the cord, and let 'er rip. Presto—the camera spins around, and you have an endless panoramic.

This camera doesn't need batteries—just a roll of film and lots of sunshine. Not a camera for night shooting or dark days, the Spinner 360 is best used with 400 or above film and lots of light with its f/11 or f/16 setting.

Scanning the images is a bit more challenging. Most labs can't scan the images with your normal film, so you either have to pay the lab to scan the images a frame at a time on a flatbed or do it yourself. Lomography also offers mail-in processing and scanning for the Spinner 360, and that's probably your best bet unless you want to scan the long frames yourself.

Oh yeah—this camera exposes the sprocket holes, too! (Sprockets are the "teeth" that grip the holes on both sides of a roll of film to advance it through the camera.)

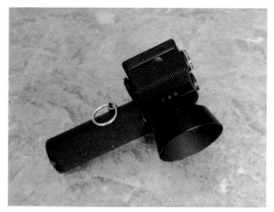

The Spinner 360.

"You simply hold out the camera, pull the cord, and let 'er rip."

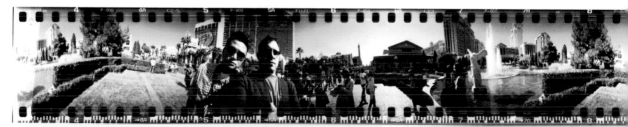

You pull the string, and whip! The camera spins 360 degrees and gets everything around you in the shot.

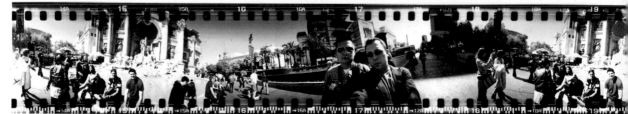

Canonet QL17

This is a tiny Canon rangefinder from the 1970s. The QL stands for quick loading, and this camera does load fast. Simply pull the leader through the film take-up reel, close the film back, advance about three times, and the camera is ready to go. I call this camera a poor man's Leica because it's about the same size and about one tenth (or less) of the price.

"I call this camera a poor man's Leica because it's about the same size and about one tenth (or less) of the price."

To be sure, this camera is nowhere near as good as a Leica, but it still takes great photos and is small, light, fully manual, and sharp. With a 40mm f/1.7 lens made of rare earth glass, I can use this camera in low light and get great shots. The lens has nowhere near the quality of today's new lens optics, but I like the magical look it gives me as it renders things. The QL17 is a low-fi camera that will create very unique-looking photos. I highly recommend it if you like the Lomo look.

I often find myself taking the QL17 out for just fun trips, when I don't want to carry my F5 or F3 with me. I can toss this camera in my glove box, and it fits fine. I love it.

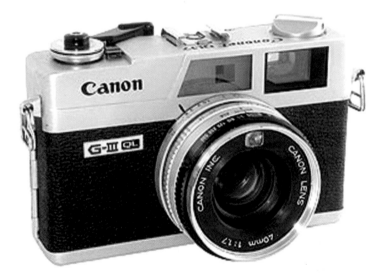

The Canonet QL17.

Images shot with my Canonet QL17.

Ingrid's Turn: Toy Cameras

Plastic cameras have become very popular over the past few years because of websites such as Lomography.com and because of social media sites and blogs dedicated to the toy camera movement. The great fun with toy cameras is that they are relatively cheap, lightweight, and fun to shoot with. They give a very distinct look because of the simple plastic lenses. Many describe the photos as dreamlike or vintage because the focus tends to be a bit soft and have a vignette.

A few popular cameras that I have personally shot with include the Holga 120mm, the Holga 35mm, and the Diana Mini. I tend to do more with the 35mm cameras, because I always have plenty of that film lying around. The cameras are small enough to fit in a purse and so lightweight that you can put one around your neck and barely notice it's there. This encourages you to have one with you at all times and play with it. It's a true toy camera.

The Diana Mini allows you to shoot single frame or half frame, turning a regular 36-exposure roll into a possible 72-exposure roll with the flick of a switch. You can blend the images or push the film to advance more to create a dividing line, depending on what you are looking for. Like other toy cameras, the Diana Mini allows you to choose a sun setting or a cloud setting for exposure and select the focal distance. It's meant to be used with 100 ISO film in daylight or on an overcast day, but you can easily use 400 ISO color negative film because of the wide exposure latitude and get great results, even under darker conditions. There is also a bulb setting for longer exposures, should you want that.

Large Format

With film, you're not limited to sensor size. Film can be cut to almost any size. 35mm is great, and medium format is awesome, but if you want even bigger images, you need to shoot 4×5 or 8×10. These truly massive cameras take photos that will wow you with the limited depth of field and the intense detail rendered from the large negative.

I've never shot these cameras myself, as I find them too big and bulky for my kind of wedding and fashion work, but I have many friends who use them, and they produce some truly amazing images. If you want to get the best image possible and you don't mind spending a lot of time getting your camera in position, locked down, and focused for a shot, then large format is the way to go.

Despite all the effort and time you will put into using a view camera, the results will be unlike anything else you can produce photographically and well worth the investment

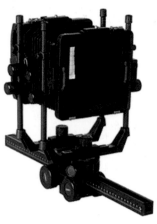

A 4×5 camera.

"These truly massive cameras take photos that will wow you with the limited depth of field and the intense detail rendered from the large negative."

Barry S. Kaplan on Large-Format Shooting

A tripod; a dark cloth covering the back of a toaster-sized box made of metal, leather, and glass; two legs; and a bent-over human descended from this odd shape, perhaps with one or both arms reaching around to the front. That was state-of-the-art photography in the 19th century, and for some it remains the highest form of photographic capture today.

The view camera in its basic state evolved from the *camera obscura*, the dark box of Alhazen and Niépce. When light-sensitive coatings were applied to metal, glass, and eventually film and inserted in the path of the light coming through the other end of the box, an image could be recorded and saved for others to see. To refine the quality of the image, lenses of glass and shutters with variable apertures and timers were placed into the front panel (*standard*) of the box. A light, tight, spring-loaded slot in the rear standard was made to securely hold the film during lengthy exposures. Film emulsions were slow, and subjects had to hold still for many seconds to prevent their likeness from being blurred. A simple but bulky mechanism was born that most people today would consider primitive in its lack of anything automatic. There was no meter to measure the light, no focus except looking through the ground glass on the back of the camera directly out through the lens, and only one shot of film at a time—and that had to be prepared carefully in total darkness. Why would anyone bother spending the time and effort to take one picture? In a word, f/64. And in other words, control of perspective, capture of detail, and ability to control the range of contrast and exposure on a sheet-by-sheet basis (Ansel Adams' Zone System), all to present the viewer with a sense of being there.

(continued)

Barry S. Kaplan on Large-Format Shooting (continued)

Using all the options available to him, the large-format photographer can present us with a view of the world beyond what our eyes and brain might have seen and processed in person. And the photographer is rewarded too, because in the process of choosing where and when to use this camera, there comes a necessary patient creativity, which is satisfying in and of itself before the shutter is ever released.

Large-format cameras are designed to use sheets of film or digital scanning backs from 4×5 inches to 8×10 inches. Larger formats are made for special purposes, but the 4×5 is the most typical format and the easiest to find film for.

The studio version of such a camera has all the controls to tilt the front and back standards, shift these standards up and down, and swing the standards around their central pivot point. All of these movements can help adjust for off-plane perspectives, place the image precisely on the film, and control focus and depth of field, or acceptable focus. The science behind how the light rays are bent is based on the *Scheimpflug principle*.

The field version has limited controls because it is designed to fold into itself for portability and light weight. Press photographers of the mid 20th century used a popular field camera made by the Graflex company. The large film size meant that contact prints could be made quickly and easily in a darkroom without the need for enlarging, a must for the fast pace of news photography in those days. Beautifully made field cameras of wood and brass with finely made controls are prized for their looks and utility.

Lenses are mounted to boards that are inserted into the front standard and held in place with sliding clips. A wide variety of wide-angle to telephoto lenses are available, and you can experiment with mounting a lens designed for a different type of camera or application with creative or satisfactory results. Most lenses have shutters built in, and as with any lens, the sharpest, best-designed ones are highly prized and hold their value.

Due to the size of the film and the need to bring a large image circle through the lens to cover the entire face of the film, these lenses are large, heavy, and not able to be designed with relatively wide apertures, compared to their small-format cousins. The result is that it takes a much smaller aperture to achieve a large depth of field than it does with smaller cameras that use 35mm or even 120 film. So while it may be common to see possible apertures of f/45 or f/64 on a lens barrel, in practice it will require a fairly long exposure and a stable tripod to use these settings to maximum advantage.

Most film types are available, including the new Kodak 10 sheets. Some films are prepackaged so you don't need to load individual holders, but these may be limited in choice and supply. There are also 4×5 backs that hold medium-format rolls of film for the dual convenience of having multiple shots on a roll and the use of the camera controls. A smaller film size will also have the effect of enlarging the apparent focal length of the lens (for better or worse), as the image circle will then cover far more than the size of the film. There are still some instant films that provide very good ways to check exposure and some that have their own artistic look and feel. These require a film holder made specifically for them by Polaroid or Fuji.

Ingrid's Turn

Joe has given quite a bit of information on each of the individual systems. If you're just starting to get back into film shooting, you should ask yourself several questions before you buy. It's also a good idea to rent a few different cameras to see what suits you best.

Choosing equipment can be a very personal decision. What feels good in your hand? Do you like to hold the camera up to your eye, or do you see things differently when you look down into a waist-level viewfinder? Do you like a lightweight camera, or do you want to feel something sturdy and powerful? Maybe you prefer a square format or the more common rectangle. Are you a quick shooter or methodical? Some will randomly choose a system, get to know and master it, and never switch. Others go through cameras like underwear and buy and sell bodies on eBay every other day. Who are you? And what tools will allow your vision to materialize?

Getting to know your equipment is key to being a good photographer because you really want the tool to be an extension of your mind and eye. You don't want to fuss with thinking too much about technical information when you're in the moment. You should know what to do intuitively and just let your fingers find the correct shutter and aperture.

You might have different cameras for different assignments. I personally like to use my EOS 3 cameras for 95 percent of my work with weddings and children. The quick, light 35mm cameras are great choices for the quickly changing conditions of a wedding or chasing down toddlers. I like to shoot instant film when I'm with friends because its immediate results allow for fun participation. I like to shoot my heavier Mamiya RZ67 camera when doing more planned, conceptual, or portrait work. And I take my plastic Diana Mini with me everywhere.

I shot the image on the left with my EOS 3 and the image on the right with my Mamiya RZ67.

3 Camera Tech and Maintenance

If you shoot digital, you know what dust can do to your images. It can ruin shots or keep you on your computer for hours, cloning them out. The issues are somewhat different with film—dust and dirt can cause scratches on your film, and you don't want that. So, you need to keep your gear clean. I clean my gear before and after every shoot. Trust me—you should, too.

All you need is a can of compressed air and some cotton swabs. I spray my cameras from the outside first and blow off any dust and dirt. I also spray the film chamber and spooling zone, but not the shutter blades. I spray the mirror and mirror chamber lightly. I then use cotton swabs to remove any gunk or greasy dirt that won't blow off. I make sure the pressure plate is smooth and clean. Finally, I wipe down everything with a lens cloth.

Many of you coming from digital photography (pro or amateur) can likely skip over the rest of this chapter, which will discuss the different ways cameras meter for exposure, metering modes, and what modes work for various situations. But then again, a refresher course never hurt anyone.

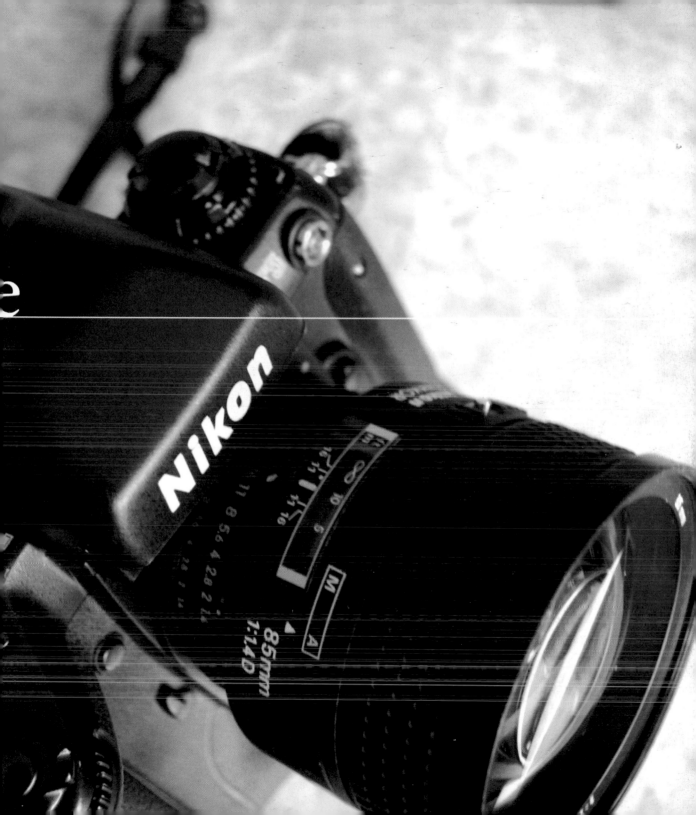

Basic Control

How a camera functions basically comes down to two mechanisms: a shutter and an aperture dial. These two mechanisms are controlled by you or the camera, and they control the light coming into the camera to expose an area of film. How you use these features determines how your photos will look.

The Shutter

There are three major types of shutters:

- Moving curtain, like that of the Nikon F3 and Canon AE-1
- Leaf shutter, as in a Canonet or a Leica
- Blade shutter, like that in modern SLRs, such as the F5 and all the Canon EOS-1 series cameras.

For the most part, each type of shutter operates the same way, with the exception of their use with flash sync speeds. A leaf shutter can sync with flash at any shutter speed, whereas a moving curtain or blade system usually maxes out at 1/250 or 1/125 for flash sync.

The shutter controls the length of time light is allowed to pass through a camera and to the film. It doesn't do anything else. Shutter speeds range from several minutes to fractions of a second, such as 1/4000th of a second.

If you're wondering what difference shutter speed makes in terms of your photos, I'll tell you that it makes a *huge* difference.

Suppose you want to photograph kids playing or a car going by. You would need to use a fast shutter speed to freeze the action. Use a slow shutter speed, and your moving subjects will be blurry.

Every photo and every subject calls for a different shutter speed. The longer the shutter speed—

"Learn to brace your camera against walls or on tables and columns."

remember, a longer shutter speeds equals a slower shutter—the more light you allow to enter the camera. If you choose a speed too fast, you might not get enough light for your image. If you choose a speed too slow, you might get blurry images.

When hand-holding a camera, try to keep your shutter speed equal to or greater than your lens's focal length for sharp photos. This helps avoid camera shake caused by you. As general rule, I always try to keep my shutter speed higher than my lens's focal length so that I don't get camera shake. For a 20mm lens, for example, I'm fine at 1/20 or 1/15, but at 180mm, I need to be at 1/200 or higher to get sharp images; otherwise, my movements will cause blur. Newer lenses with vibration reduction and image stabilization can compensate for slower shutter speeds. This won't freeze a moving subject, but it *will* save your shot from being blurry due to your hand movement. If you're shooting on a tripod, this is of course irrelevant, because the tripod alleviates camera shake.

When you're shooting people, speeds of 1/60 or higher are usually fast enough to freeze subjects, but for anyone moving or walking, such as a bride walking down an aisle, I like to use at least 1/125 or higher.

For slower shutter speeds where you want to suck in as much light as you can, be mindful of camera shake—but realize that you don't always need a tripod. Learn to brace your camera against walls or on tables and columns. I have gotten sharp images with no motion blur at shutter speeds as slow as 1/8 by simply bracing the camera against a wall.

These images may not be tack sharp, as if I were shooting at a higher shutter speed and aperture, but they captured the moment I was shooting. For landscape photographers, you are better off using

For this shot, I braced my camera on a chair to keep the shot steady. I shot it at 1/8 at f/2 and ISO 400.

a tripod and getting the shot perfect. For me, as a wedding photographer, it's just about getting the moment any way I can. I can't lug a tripod around a reception with me.

Aperture

The aperture controls the amount of light that will expose your film. Aperture readings are measured in *f-stops*. F-stops on most lenses range from f/1.4 to f/22. There are faster lenses that can open up to f/1.0, and some lenses can stop down to f/64. Smaller f-stop numbers correspond to wider apertures, and vice versa. The wider the aperture—for example, f/1.4—the more light is passed through your lens to the film. The smaller the aperture—for example, f/22—the less light you allow to pass through.

The aperture determines your photo's depth of field. The larger the f-stop (and the smaller your aperture), the larger your depth of field. The smaller the f-stop (and the wider your aperture), the shallower your depth of field.

The effect f-stop has on depth of field or apparent focus is different on every lens. Wide-angle lenses have more depth of field at a given f-stop than telephoto lenses have at the same f-stop, due to the compression created by telephoto lenses. For example, if I were taking a group shot of three rows of people, I could get away with f/4 on a 20mm lens, but on a 50mm or 80mm, I might need f/8 or f/16 to keep the same three rows of people in focus. All you really need to know is that wide-angle lenses have a larger depth of field than telephoto lenses.

If you want to create shots with shallow focus, where your subject is in focus and everything in front of and behind your subject is out of focus, then use small f-stops, such as f/1.8 or wider. If you want images where everything is in focus, from foreground to background, then use large f-stops, such as f/16 or f/22.

This has nothing to do with lens sharpness—the depth of field is what is in apparent focus on a given lens with a given f-stop. Some lenses are not equally sharp across all f-stops; some are sharper when stopped down or when wide open. It depends on your lens and how it was manufactured. Typically, more expensive lenses are sharper at wide-open apertures, such as f/1.4, versus always being sharp at f/2.8.

Fast Lenses versus Slow Lenses

When it comes to describing lenses, many people describe them as being fast or slow. This has nothing to do with how fast a lens can focus automatically or manually; it refers to how wide open it can shoot. Lenses that are f/2.8 or wider, such as the Canon 50mm f/1.0 lens, are referred to as *fast* lenses because they can shoot in lower light than slower lenses—those with smaller apertures, such as f/3.5, f/4, and higher. This is why Leica lenses cost so much—they are fast *and* sharp.

NOFEAR

Mix things up! Try shooting things totally opposite of what you normally do. If you always shoot with a zoom, try a prime lens, or vice versa. Try shooting with a wide-angle lens instead of a telephoto.

A slower lens, such as an f/4 lens, needs much more light to expose for an image than, say, an f/1.4 lens would. More light can pass through an aperture of f/1.4 than an f/4. The aperture is a diaphragm ring in the lens that opens and closes.

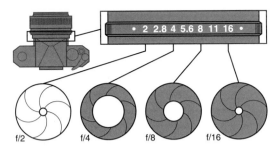

Aperture ring.

However, just because a lens is fast—say, f/1.4—that doesn't mean it will be sharp at f/1.4. This is where things can get tricky. The quality of a lens and its sharpness, bokeh, and speed are all independent of the lens's design. Every lens is different. Some lenses are very soft, and some are very sharp. It's best to test a lens before buying it—you can rent one or review it online as much as possible. Generally speaking, the more a lens costs, the better it will be overall—but this is not always the case. If you need to shoot in low light, then you will need a fast f/1.4 or f/1.8 lens—but just know that at those f-stops, there may be some vignetting in the image, and it may not be tack sharp.

Vignetting

Vignetting is when your image appears to be brighter in the center and darker around the corners. This is caused from light falloff. When shooting at wide-open apertures, light can be stronger in the center of the image and weaker around the edges and corners. This is typical of shooting on many fast lenses. Vignetting is usually not visible at f/4 or higher.

Bokeh

Bokeh describes the quality of the out-of-focus areas in an image. Good bokeh is considered to be when the out-of-focus areas are soft and milky smooth. Bad bokeh is considered to be harsh and not smooth. This is totally based on your personal opinion, of course. Bokeh is just the quality of the out-of-focus areas in the frame. Whether it's good or bad is totally up to the viewer.

Metering

Let's start with the basics. Cameras with meters built in read the light reflected to them through the lens or a meter window and calculate exposure based on 18 percent gray. That means your camera is looking to make your image as close to 18% gray as possible. If you have a pretty diverse image of both light and dark objects, your meter should be fine, but it can easily be tricked if there are objects that are super bright or overly dark in much of the frame. This is why it's good to know how to meter and what metering options your camera offers.

Film cameras can have several types of metering modes. The most common is center-weighted. In this mode, the camera meters about 40 to 60 percent of the center area of the film frame. This area is usually outlined by a circle in the viewfinder. In center-weighted mode, the camera reads the reflected light from only that area and gives a general exposure. This mode is good for general shooting.

Next is average metering, in which the camera reads the entire frame, averages all of the readings, and creates a general average or middle exposure for the frame. This mode is good for scenes that have the same contrast and look all over, such as a shot of a forest or a mountain, where everything is pretty much the same in the frame. It's not one of my favorite metering modes, but it's good to have in case you need it. I prefer matrix/evaluative metering over this mode.

Next is spot metering. I use spot metering 90 percent of the time. In spot mode, the camera reads only the light reflected from the tiny circle in the camera viewfinder for the selected focal point. It ignores everything else in the frame to give you an exact reading of what you have selected. When I'm shooting a model or a bride who is backlit, I can just spot meter for her face and not have to worry about the camera exposing for the bright light behind her, which would result in her being dark or silhouetted. I use spot metering in any situation

where I'm trying to meter for a specific region of an image. Sometimes I take multiple spot readings and then average them myself to get a decent exposure. For example, I might take a reading off of a few tree trunks in a forest, and if one tree is f/5.6 and another is f/8, I would likely shoot at f/6.3 or f/7.1

NOFEAR

Want to be sneaky? You don't always need to look through the viewfinder; you can set a wide-angle lens to a preset focus range and exposure and then just shoot from your hip when you see something in range of you. This way, no one sees you and reacts to you taking a shot.

Taking multiple readings allows you to know where the highlights and shadows fall in your image. With some color films, such as Kodak Portra 400, I take a few spot metering readings and then set my camera for the shadow area of my frame, knowing that the highlight detail won't be blown out, and I will be able to capture the detail in the shadow area as well. Spot metering allows me to figure this out by simply metering on the desired focus points.

Finally, there is the king of modern metering: matrix/evaluative metering. This metering mode utilizes computer processing by the camera. The frame is divided into many separate regions that the camera reads, and the camera also takes into account the focal point you have selected, the distance to your subject, and even color. It also takes into account thousands of exposures for other images that have been programmed into its memory. In other words, it's thinking about your photo and not just reading light and averaging reflections.

"I use spot metering in any situation where I'm trying to meter for a specific region of an image."

A good example of this would be a sunset image. In center-weighted or average mode, the camera would see the sun and place a lot of value on it because of its brightness, which would result in a dark photo. But in matrix mode, the camera will only see the sun as part of the frame and should take into account the dark areas of the image and expose for them, because they take up more area than the sun does. I use this mode for landscapes or for vast room shots, but I don't use it for portraits or weddings.

Depending on how old your camera is, it could have several metering options and ways of reading the information out to you. Many older cameras with metering systems use a match-stick or needle method. When you look through the viewfinder on these cameras, on one side of the frame you will see aperture or shutter readouts with a needle or stick that goes up or down, depicting the shutter speed or aperture it's reading. This method is simple, and it works. Most newer cameras will be reading out the aperture and shutter information to you in an LCD in the viewfinder. Many older cameras don't even have built-in metering. It's up to you to learn the camera you have and how it works.

No single metering system is right for every shoot, so learning how to use all of them will allow you to be prepared for any situation. I forgot my Sekonic light meter at a recent wedding and was forced to use the meters in my F5 all night. I changed the metering pattern constantly as the day went on and as what I was shooting changed. The F5 never failed me. I just took into consideration the Sunny 16 rule and paid attention to what I was shooting.

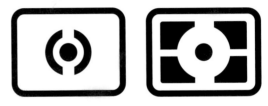

Metering mode icons.

Exposure Readout

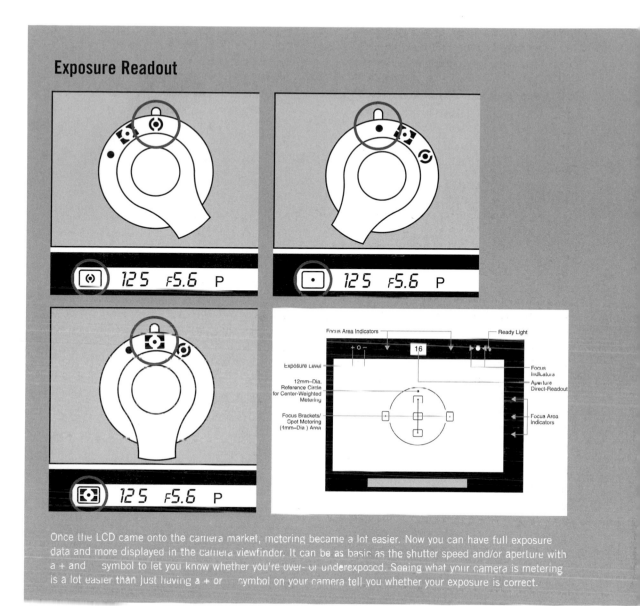

Once the LCD came onto the camera market, metering became a lot easier. Now you can have full exposure data and more displayed in the camera viewfinder. It can be as basic as the shutter speed and/or aperture with a + and – symbol to let you know whether you're over- or underexposed. Seeing what your camera is metering is a lot easier than just having a + or – symbol on your camera tell you whether your exposure is correct.

"No single metering system is right for every shoot, so learning how to use all of them will allow you to be prepared for any situation."

Light Meters and Quality of Light

Light is what allows you to capture your images on film. That can be light from the sun, from a camera flash, from room lights, or from any other artificial light source. The point is that you need light. Light molds your subjects—people, buildings, mountains, and vast landscapes. Learning to find the best light or to use and modify the light you have takes a lot of practice and time.

You need to learn to find the best quality and strength of light to fit your needs. All light has qualities—it's up to you to find the light with the qualities you need. Light can be strong, harsh, warm, cool, weak, soft, or hard. So what do you need it to be?

Whenever you're doing a shoot—whether it's a portrait session, a wedding, or just a personal project—you should do some research beforehand. I like to Google where I will be shooting and check out everything around the location via online maps and satellite photos. Then, if I can, I like to go and personally walk around the location at the same time of day that I will be shooting, so that I can get a sense of the actual light there. I don't always get the chance to do this, though—if not, I just have to go with it and think fast.

This is why a light meter can be your best friend. With it, you can quickly judge the strength of the light, and with your eyes you can judge the quality. In time, you'll be able to quickly judge the qualities of light, and you can use your meter to judge whether it's the right light for you or whether you need to move on or modify it.

Light meters.

Finding the best light to work with and using that light is not always easy. For example, at a recent wedding I was shooting, we were taken to a rose garden in a park at around 4 p.m. It was summer, and sunset was at about 9 p.m., so the sun was right overhead, creating very harsh and unflattering light. I wanted to show the warmth of the garden and the beauty of the wedding party, but I only had about three minutes to figure out what I wanted to do.

First I looked for shade, but then I looked for shade filled with reflected light from some concrete. I didn't just want dark shade; I wanted shade with beautiful warm light from the garden and concrete reflected in. I saw a sort of Roman temple that was covered in beige paint and filled with warm light from the garden, and it was out of direct sunlight. It was backlit, and that's where I decided to shoot the wedding party. The structure was open-walled with Roman columns and a roof, with one wall to a grassy field and the other three to open light. The light was mostly coming in from the front, and the sides were acting as fill lights, bouncing in light from the surrounding plants, so the light was being tinted green but was still warm. I let the warm light wrap around the subjects, backlighting them and creating well-lit shots. I didn't use flash or any reflectors; I just used my environment to modify my shots. All I had was my camera.

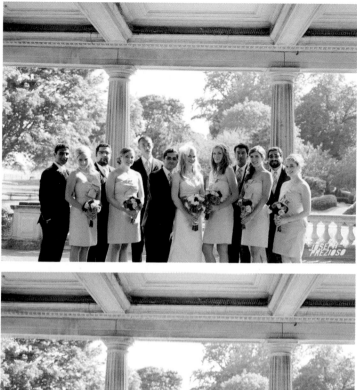

See how the light being reflected from the plants and green surroundings caused a slight green cast? I could have taken it out in post-production, but I liked it.

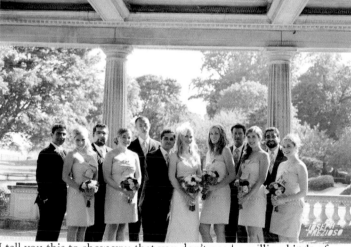

"[L]ight is very much like the Force. It surrounds us and fills our photos with life."

I tell you this to show you that you don't need a million kinds of flashes, reflectors, or light-modifying tools to get well-lit shots. Just look around, do some homework, and learn to feel the light. To use a *Star Wars* analogy, light is very much like the Force. It surrounds us and fills our photos with life. Without it, our photos are nothing.

4 Current Film Stocks

"Every film mentioned in this chapter is a type I have used and love."

The films available today are very different from the films that were around even just 10 years ago. Not all of the films that were around (even the great ones) made it through the digital age to the new film age. Many films just didn't sell well enough to keep production going, so sadly, they died. The films that have survived are some of the better—or shall we say more widely used—films, such as Fujifilm Superia, 400H, and 800Z; Kodak's Portra and Tri-X lines; and the popular Ilford black-and-white films.

I will talk about these films in this chapter, because they are currently available and ready to shoot with. Many expired films are readily available and can be great fun to use, but I want to talk about films that you can get in a pro-camera shop or order online. Every film mentioned in this chapter is a type I have used and love.

With film, you can get very custom looks depending on how you shoot and develop it. Finding the right film for the look you want can take time. I highly recommend ordering a number of different films and trying them out. There is no better way to learn about a film than to test it yourself.

When I test a new film, I throw a roll into my camera and then set the meter (in camera or by using my handheld meter) to the film's box speed (the ISO at which the film manufacturer has rated the film to be shot), and find a subject—usually my dog, a person, or a flower. I then take several shots: one properly exposed and then two shots in either direction of the meter. (This technique is called *bracketing*—you take the same image but at different settings.) For example, I might take a photo on ISO 100 film in full daylight at 1/125 at f/16, which is the proper exposure for something in full sunlight on ISO 100 film. Then, by bracketing, I would go to 1/60 and 1/30, overexposing two stops. If I wanted to underexpose the shot, I could do 1/250 and 1/500.

So in essence, to test a film—say, a 400 speed film such as Superia 400—I will take shots of the same subject, bracketing as if the film was rated at 100, 200, 400, 800, and 1600. Then I will have the film developed normally and compare the shots. I do this in different lighting situations and with different subjects. This helps me determine the latitude of the film and how it reacts in different situations, and it gives me knowledge of how it will perform. I generally get prints and lay them all out on a table so I can compare the shots side by side. I find there is no better way to learn about a film than to see it printed and side by side.

Kodak Portra 160

Kodak Portra 160 is my go-to daylight-shooting, outdoor film. Formerly available in natural color and vivid color stock, it has been redesigned with finer grain and the color shifted to that of a more natural, less saturated look. I shoot this film in both 35mm and medium-format sizes. It always looks great, from sunrise to dusk, but it's not for low light or indoor shoots without flash. This film needs a lot of light. I meter for this film at ISO 100—as you will find out, I like to overexpose my film to really burn in the shadow detail. At 160 this film is good, but I love it at 100 and sometimes at 80 on overcast days. The color is really natural, as expected, and it's great for portraits and people shots.

"I like to overexpose my film to really burn in the shadow detail."

Images shot on Kodak Portra 160 film.

Kodak Portra 400

Kodak Portra 400 is another brand-new film that replaces the older NC and VC versions. This film was based on the Kodak movie-film line and hence has the super-fine T-grain emulsion. This is probably my favorite new film from anyone. It is slightly saturated and makes colors pop. The super-fine grain is ideal for a speed of 400, but what makes this film amazing is its latitude. I can shoot this film; expose it as if it was a 200, 400, 800 or even 1600 film; process the film normally; and get back great photos. Kodak Portra 400 was made for low-light shooting, for shooting with and without flash, and for those times when your lighting is changing so quickly that you need one film that will allow you to keep shooting without worry.

"[Kodak Portra 400] is probably my favorite new film from anyone."

Portra 400 is my go-to wedding film for color negative for low-light receptions. Daylight balanced, it handles tungsten light and fluorescent lights very well. I like to shoot this film at 250 for portrait work when I want a more saturated look with finely detailed shadow areas. When shooting weddings, I rate it at 800 and then just meter and overexpose when I can. I have even shot this film at 1600 with no flash and just had it processed normally at a one-hour photo processor and gotten back great shots. I prefer to push it one stop if I'm going to rate it at 1600, but you don't have to. This film was made for low light.

Kodak Portra 400 at 1600 with a one-stop push from a concert I shot in Cambridge, Massachusetts. I just metered and shot the film as it was, at 1600 ISO. I love the color and the contrast I got back.

Metering

When I meter for any film or camera, I try to use my Sekonic handheld meter, set the ISO on that, and take a reading. I also use my in-camera meters. Some cameras have better meters than others; it's up to you to learn how to best use the meter you have.

These images were metered at 250 and developed normally.

NOTE

See Chapter 7, "Pushing Film," for more information on pushing and pulling.

These images were rated at 1250 with a two-push in development.

Kodak Ektar 100

If you love color, Kodak Ektar 100 is the film for you. When I want to show super-saturated images with no grain, this is the film I turn to. It reminds me of the old Agfa Ultra 50 I used to shoot in the 1990s. This is a landscape and vista film. I use it for wedding shots, when I want to show off large views and wide shots. However, I don't like to use it for portraits because it makes some people look a little tanned or orange, depending on their skin tone.

Ektar 100 is available in formats from 35mm to 8×10. Kodak launched this film to reestablish itself as a leader in film formats. Shoot this film in 120, 220, or large format, and no digital camera will come close to producing such a flawless image with such smooth grain. It is the finest-grained film I have ever used.

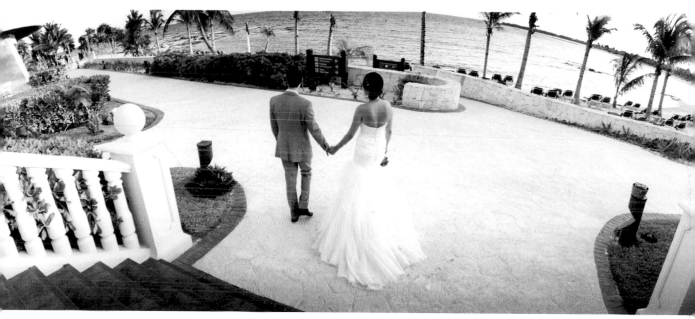

Images shot on Kodak Ektar 100 film.

Kodak Tri-X 400 and Ilford HP5 Plus 400

Kodak Tri-X 400 and Ilford HP5 Plus 400 are my go-to black-and-white films. They are very low grained, sharp 400 speed films. Being black and white, they are also very pushable (see Chapter 7 for more on pushing), and I generally shoot these films at 1600 or 3200 and rate them a third of a stop or less when I meter. In other words, if I'm going to use the film at 1600, then I meter for 1250; if I'm going to use it at 3200, then I meter for 2500.

I don't like to overexpose BW film because it's not like color negative film, which holds the details in the overexposed areas. I find that sometimes it better to slightly underexpose, get less contrast, and then add the contrast in scanning or post-production.

BW film is very unique in that its look can be very personalized by the way you shoot, develop, and scan it. There are a variety of different developing solutions for these films—some that will reduce grain, others designed for speed. You have many choices.

"I don't like to overexpose BW film because it's not like color negative film, which holds the details in the overexposed areas."

NOFEAR

What—you brought the wrong film? Get over it—shoot it at what you need it to be and have your lab push process it. You will be amazed at what film can do.

When shooting people with fair or pale complexions with this film, make sure to overexpose a third or more of a stop so that they don't end up gray and underexposed. (So, for example, if your meter is telling you f/2.8, I would shoot at f/2.2 or f/2.) Your camera meter will want to make things neutral gray and flat, so neutral gray in BW is gray. Just a heads up.

Both of these films are available in 35mm and 120mm formats.

Pushing Film

Some films are pushable—that is, they can be shot and developed as if they were a high-speed film. This is done in two parts: First, if you're shooting a roll of, say, 400 film, you set your camera meter or handheld meter at 1600. Then you have the lab push the roll two stops. This means they will keep the film in the developer longer, increasing the contrast and changing the gamma curve of the film. If you are going to push film, make sure to shoot it at the same setting for the entire roll.

Images shot on Tri-X 400 and HP5 Plus 400 film at 1600.

Kodak TMZ 3200

This is a great film. I haven't shot a ton of it, but every time I've used it, I've been very pleased with the results. It's a high-speed true 3200 film. By "true," I mean that you can shoot the film at the box speed of 3200 and get good shots. However, I always rate it at 2000 or 2500 and meter for the highlights in an image to get better contrast.

If you're going into a low-light situation, this is a great film to have on hand.

Images shot on Kodak TMZ 3200.

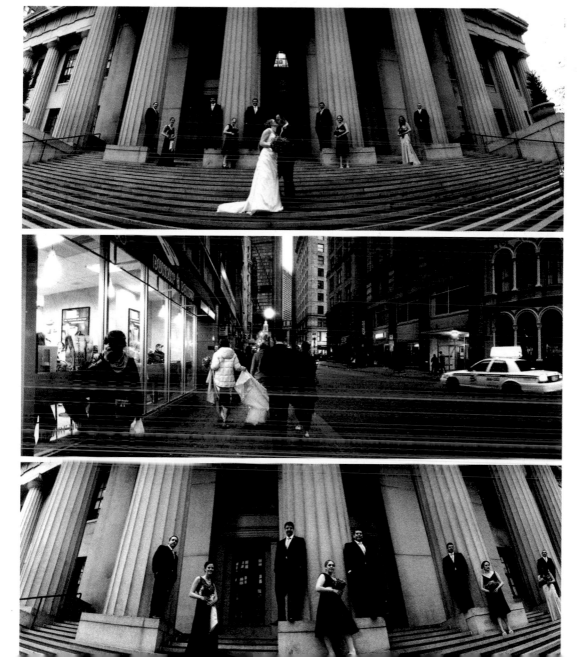

Ingrid's Turn: Kodak BW400CN

Kodak BW400CN is a great black-and-white film that is processed as typical color negative film. It has the same wide exposure latitudes as the other Kodak color negative films and can be overexposed by a few stops while still retaining detail in the highlights. This is my favorite black-and-white film to shoot for weddings because it is so versatile. It has a fine film grain and nice tonal range.

Images shot on BW400CN.

Ilford Delta 3200

"I love, love, love this film."

Ilford Delta 3200 is my go-to high-speed BW film. I love, love, love this film. It has awesome grain structure and gives you the ability to create beautiful images in both daylight and no-light situations. I use this film in both 120 and 35mm versions. When I load it into my Pentax 645 and shoot, it gives me great contrast and low grain for a 3200-speed film. When I shoot it in 35mm, I get lots of grain and less contrast in the image. You can get two different looks because of the way the grain resolves into an image in different image-capture sizes.

I rate this film at 2000 when I shoot it, and I always meter for the highlights. I like the high-contrast look it gives me. If you want less contrast, just meter it on the highlights at 3200 or push it to 6400 for those super-low-light situations.

Images shot on Ilford Delta 3200, taken on my Pentax 645 at a wedding and in daylight situations.

Fuji Superia 800

This film is marketed under many different names—some discontinued and others still around. Fuji has many films in Japan that you can't always get in the U.S. When I shot tons of this film, it was called Fujicolor Press 800. The only difference between it and the Fuji Superia 800 film was that it was kept refrigerated to help control the film's quality. As of this writing, you can still get this film in 24- and 36-exposure rolls.

I have always loved this film. It's not a low-grain film; it's a grainy film. It has a unique, very "newspaper" look that I fell in love with. I rate this film at 640 when shooting it, and I always overexpose.

Superia 800 film needs light. It can also be shot at 1600 with a push in processing to help with the contrast. I have shot this film at weddings, rated it in camera at 1250, and had the lab push it one stop with great results. In low light, the shadow detail won't be great, so overexpose when you can and use flash as well. When rated at 800 and developed normally, you can get a nice washed-out look, too—even better if the film is expired. It's one of my favorite films for a truly unique film look.

This film has a big brother called 800Z, a pro version of it. I have not shot 800Z in a long time, but I expect it is very much like the Fujicolor Press, and I would shoot it at 640 and tend to overexpose.

"[Superia 800] is one of my favorite films for a truly unique film look."

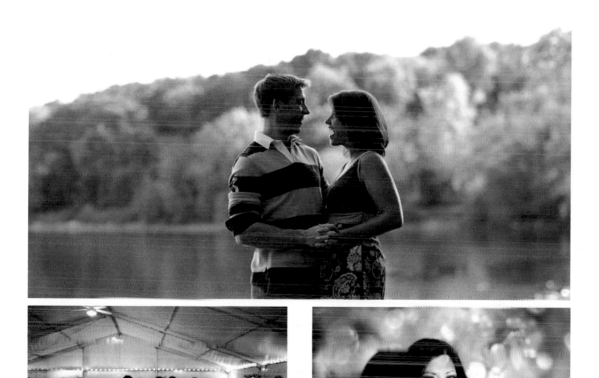

Images shot on Fuji Superia 800 with and without flash.

Fuji Superia 400

Superia 400 is a consumer film that Fuji makes and sells around the world. I love this film, too. It's a high-contrast and saturated film, but with great latitude. I have shot this film at 200, 400, and 1600 and gotten pleasing results. I don't really like to shoot it at 200, though, because it's already a high-contrast film; I find it works best at 400 and 800.

If I shoot it at 800 or 1600, I like to overexpose as much as I can with respect to what I'm shooting. I shoot this both for personal work and at weddings, for shots of people dancing or just general-coverage shots. I wouldn't use it for portraits unless I was going for a high-contrast look.

Images shot on Fuji Superia 400. I took these in Washington, D.C. at the National Harbor while walking around and experimenting with the film's look.

Ingrid's Turn: Fuji NPH 400

Fuji NPH 400 is a very popular film with wedding shooters because when you overexpose it, it makes for a wonderful creamy skin tone and brilliant green tones. It is a great versatile film for portraits, food shots, and scenery. I rate this film at 100 or 200 ISO. As with the entire Fuji line, the green tones are so beautiful that it's nice for landscapes, too. It works well in open shade and on cloudy days. When you overexpose the film, the contrast levels are bumped up.

Images shot on Fuji NPH 400.

Fuji Sensia and Cross-Processing

Fuji Sensia is pretty readily available; I see it everywhere, and I have tons of it. A consumer slide film, it has great color and low grain—but that's not why I like it. I like to shoot this film and cross-process it because of the red color shift it creates. When cross-processed—that is, developed in C-41 chemistry as opposed to E6 chemistry—this film gets awesome, with a magenta cast and crazy red glows. It's a really cool look that I love to play with and use for street shooting. You never know what to expect, but you can always expect something spectacular.

NOFEAR

Experiment! Don't be afraid to cross-process your film for cool effects.

Different films—even films in the same family, such as Sensia—will color shift differently due to their different chemical compositions. Sensia 100 shifts to the red and magenta spectrum, while Sensia 200 shifts to the green and yellow spectrum. Other films, such as Kodak 100G, just get very contrasty and sometimes shift to cyan. Every slide film will process a different way, so find the one you like and exploit its look for your own pleasure. Just test it before you shoot something important with it.

Cross-processed images from a day of shooting in Las Vegas. I used my F3 and Sensia 100—check out the cool color shift. I love it!

5

"The person scanning your film is ultimately responsible for how your image will look."

The Hybrid
Workflow

You have a film camera, you shot something, so now what? You need to get your film developed and into your computer. Yup, into your computer. This is the modern age; prints just don't cut it anymore. You need high resolution and quality scans to edit, sort, and present, all via computer. So what do you do?

There are a few options and price points for getting your film developed and scanned. These options vary from user to user and are based on your end goals and needs. First I'll go over what I do; then I'll talk about the other options available.

I shoot weddings. That's my gig, so I need to be able to present almost 1,000 photos to a couple after their wedding via an online gallery where they can peruse the images and order prints. For this I first need to get all my images scanned, edited, and sorted. At times I have to remove unwanted items in an image or clean up some of the bride's or groom's skin blemishes, so I need high-res scans. To accomplish this, I send all my film to a professional lab that will develop my film and then scan my images to 6 or even 11 megapixels—whatever I ask for. I generally get 6-megapixel scans, because that's large enough for an 11×17, and if a client wants to go bigger, I can always have one or two frames rescanned at the higher resolution.

Labs today use two primary scanners for bulk roll-film scanning:
Noritsu and Fuji mini lab scanners. Both are great machines,
Google them, and you will find tons of blogs about how people love
the color on a Fuji Frontier or how they like the sharpness of the
Noritsu better for black-and-white images. The machines are pretty
powerful and are great for getting your images from negatives and
onto the computer. I use the Noritsu just because it's the most
common machine offered by many labs, but truthfully, I believe
that getting a good scan from these machines has more to do with
the person doing the scanning than with the actual machines. The
person scanning your film is ultimately responsible for how your
image will look. He or she has the ability to adjust contrast, chroma,
sharpness, graininess, color balance, and brightness.

I shoot film because I love the way it looks and the incredible latitude and highlight retention it has, but if I have, say, Walgreens scan my film, then the whole point of shooting film in the first place is gone. If the person scanning your film doesn't care much about image quality or doesn't know about the latitude of the film you shot, you may get back oddly colored shots and images that just don't look how you expect they will. For that reason, I highly recommend finding a great photo lab, such as Richard Photo Lab, North Coast Photo, or another pro lab that understands film and will work with you and talk to you about how you want your film scans to look.

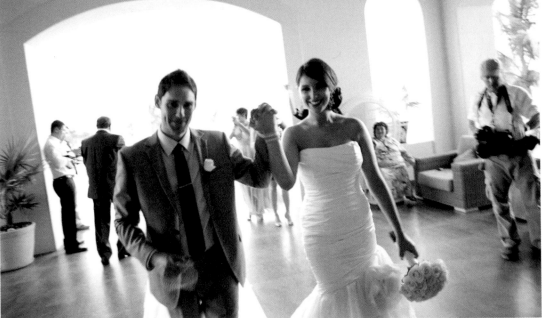

These pairs of images show you the difference the scan operator can make.

My workflow for this is now very simple, as the lab I use knows my look, how I like my color and contrast, and how I shoot. All I have to do is mark my rolls, fill out a developing sheet (for the lab), overnight my film to them, and then wait for a DVD in the mail or an email with access to an FTP site to download the images.

NOFEAR

Don't be afraid to talk to your lab and tell them how you want your images to look. If you don't discuss what you're expecting, they can't give you what you want. The lab's job of developing, scanning, and printing is highly customizable.

The next steps are very important! I download all the images to my computer and import them into Aperture. I then spend about 10 minutes sorting them and about an hour making any small adjustments that I want. Then I export them to my online gallery, and the images are ready to be viewed and admired. That's it.

If you're not shooting events or you shoot fewer events, you are super-critical of your images, and you want the ultimate scans that capture every nuance of the negative, then you want drum scans or a good dedicated film scanner with high dynamic range, such as a Coolscan V or an Imacon. These scanners are made to scan a frame at a time, not rolls in minutes. So in the time that a Noritsu would scan a roll, these machines would scan a frame or two.

The difference is very visible in the final image. When the Fuji and Noritsu machines scan images, you get JPEGs that are more or less close to the final image; they aren't Raw files, which is why it's up to the person scanning your film to make all the adjustments during the scan. With dedicated scanners, the workflow is a bit different. These scanners do multi-pass scans that scan the frame for shadow and highlights on many levels and create large image files, like those of a Raw file from a digital camera. You can then open these files in Photoshop; they are huge and editable to the full extent of the information the

Making adjustments to an image in Aperture.

negative had. This is great if you're just doing personal projects or you need images blown up for an art gallery or presentation, but for me it's just too slow and expensive. Drum scans aren't cheap.

Now the cheap option… This will totally consume your time, but it's an option nonetheless: Use a cheap flatbed film scanner. When I say "cheap," I mean that they are less than $1,000, which is cheap compared to a dedicated film scanner. However, as with all compromises, there will be differences. You won't have to pay someone to scan your film rolls (most labs charge $5 to $15 per roll); you will usually have your film developed for less than $5 a roll. But now you'll have to scan your rolls a few frames at a time and deal with dust on your flatbed, dust on the negatives, and the speed at which your scanner operates. Most flatbeds also don't have the quality lens or high dynamic range of the dedicated scanners that most labs use, so your images will look good for web usage, but they won't stand up to scans done by lab scanners.

This is what I use flatbed scanners for—to create contact sheets.

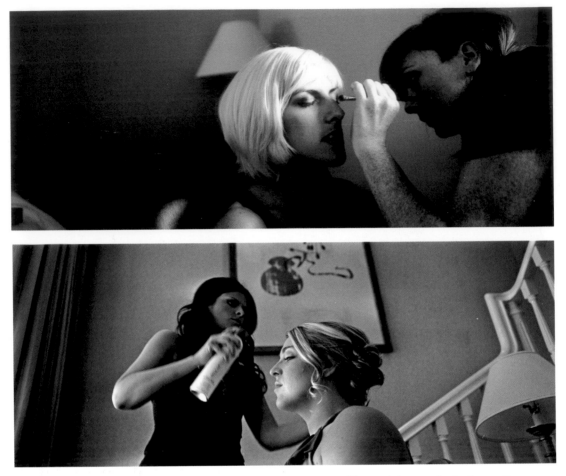

Alternatively, you can use this method to make contact sheets, send out just the individual frames you want scanned, and get those scanned at the best resolution you can afford.

With all scanning methods, there is always the issue of dust. Whatever method you use or whichever lab you choose, make sure your images are dust free. Nothing ruins your day like getting back a ton of photos from a shoot and seeing dust spots that you need to remove on all of them. A small particle of dust here and there is acceptable to me, but not all over the place and on every frame.

Images with scratches or dust all over them aren't acceptable.

If you're scanning your film yourself, the best way to remove dust is to use compressed air to spray any dust or particles off it. You can use an air can, but be careful to hold it correctly so that fluid does not spray out onto your film. I prefer to use a small air compressor with a spray-nozzle attachment, readily available at most hardware stores. These compressors have no fluid and can't damage your film.

"Nothing ruins your day like getting back a ton of photos from a shoot and seeing dust spots that you need to remove on all of them."

Other things to watch for include tar and leftover chemical residue on your negatives, or underdeveloped or improperly developed negatives. If you choose a lab that doesn't run a good amount of film, chances are that their chemistry is not in check or up to the standards required to develop the film properly. Dirty machines with poor chemistry can do horrible things to your film. So make sure you pick a lab that's healthy—one that runs their film properly or runs enough of it to make sure their machines stay workable. Dirty machines can scratch and ruin your film. Not fun.

In the end, it's about getting your image off the negative and onto the computer so you can share it with the world. Whatever options you choose to do so have to be right for you.

See the weird glob near the top right of this image? That's something the developer left on the film.

Ingrid's Turn

The hybrid workflow takes the best parts of analog and adds the ease and flexibility of the modern world. I tell my clients that I use traditional capture with modern perks. By scanning in all my film, I can share online, print from digital files (though traditional printing does have a certain look to it), and do some simple printing techniques in Photoshop (which is easier than working in the dark).

I love using a hybrid workflow on the back end of my photographic process. One perk to scanning your film is that you really can see your images up close and personal, in a fairly organized way. Unlike the old ways of developing film and making a contact sheet or proof prints or viewing negatives with a loupe, you can now see what you have in full size and decide what's worth working on. This also gives you a better way to store images and categorize them for future reference. I can't tell you how many thousands of loose negatives I have stored in unmarked photo sleeves in boxes in my closet. Importing images into a program such as Adobe Lightroom, naming them, and creating a matching label for your sleeved negatives is super simple. You can print from your scans *or* from your negatives.

Sharing images through digital media is an added bonus to the advances of the digital age. Art buyers, clients, networking groups, and the like are all using the Internet to share images. Because of digital capture, there are literally trillions of images floating around out in the ether. But now, we film shooters stand out because of the smaller percentage of photographers actually using film. There are many groups out there dedicated to the classic analog craft; we are not completely alone! I promise. You can find them on Tumblr, Flicker, Facebook, and the like.

Developing

So you've shot your film. You can send it to a lab—which is what I do and recommend—or you can develop it yourself. You can develop both color and black-and-white film by hand at home. Developing BW film is relatively simple as long as you have all the chemistry, but developing color is a much more demanding and sensitive process.

6

Color film has to be developed at precise temperatures for precise times. Even the slightest change in temperature can cause your film to be pushed or pulled. With that said, you can buy many at-home color-developing C41 kits. Just be sure to keep the temperatures precise and to watch the time of developing. Temperature is super-critical. I had my lab friend try to hand-develop color film one day by siphoning chemistry from the mini lab and using the BW film-developing canister. We achieved good results, but I think it's just safer and easier to use the mini lab processor. It was hard to keep the temperature constant.

NOFEAR

"Do or do not; there is no try," said Yoda. So just keep shooting. If you mess up on your first few tries like Luke did when he was training, don't worry. Just keep practicing, and you'll become a Jedi at using film.

"One wrong step, and you could ruin your film."

Black-and-white film, on the other hand, is fun to develop. It can be done at many temperatures, and the time changes with the temperature, so it's less critical. Room temperature (68 degrees) is what I believe my lab develops at, and they push or pull the film by keeping it in the developer for a longer or shorter time.

You push or pull film when you shoot it at a speed different from the film's box speed. So if I shot Portra 400 at 1600, I would have the lab push it two stops, which means they'll keep it in the developer longer. If I shot it at ISO 100, then they would keep it in the developer for a shorter period of time.

Black-and-white film developing requires fewer chemicals, too. You have the developer, the fixer, and some washes. There are many kinds of developers from Kodak, Ilford, and other companies that all do different things. By using different developers in combination with different films, you can control grain size and contrast to get the look you want. BW developing is not as strict as color developing and can be customized to your liking, so there is an incentive to develop BW film yourself if you want to achieve a personalized look.

I highly recommend that you develop test rolls with shots of nothing important before you ever do a roll that's important to you or a paid gig. One wrong step, and you could ruin your film.

Also, keep in mind that the chemicals are not all that ecofriendly, so you will want good ventilation and storage for used and unused chemicals. And dispose of chemicals properly—it's not safe to pour them down your drain.

Barry Kaplan on How to Develop Black-and-White Film at Home

Barry Kaplan is the owner of the Finer Image Photo Lab in Danvers, Massachusetts.

Black and white from a lab rat's perspective... Well, not entirely, since I have been a photographer for longer than I've been developing and printing my own and others' images. My current photo business primarily comes from pros, mothers, and businesspeople who want to know someone is looking after their images in a curatorial way. We cater to their desires to keep it warm, cool, cropped perfectly for framing; match the color to another copy; and so on.

When I make the occasional suggestion of "Let's see how it might look in black and white," the usual response is, "Ooh, I love black and white!" So why don't we see more of it—especially in a digital world, where the conversion starts easily enough with a mouse click of desaturation? Why is it that BW film photography has been left in the hands of students and fine-art image makers?

The biggest culprit is probably the time needed to shoot, develop, and create a BW image from film, yet it's well worth the investment and perhaps not as daunting as a new photographer might think. After all, it's what we learned to do in high school, and we often had to wait until sunset to set up if we didn't have a dark closet in the house.

With a well-exposed and well-developed negative and a good scanner, I think we have a historically new and great ability to create and manage fine images. Whether you choose a good old 35mm camera or a medium-format tool like my Mamiya RZ or Pentax 6×7, the process is pretty much the same.

1. **Seeing.** Teach yourself to see shades of gray and tones of light. Shapes, shadows, and highlights will appear where you previously only saw colors.

2. **Shooting.** Learn to expose your film properly, using the camera's meter or a handheld one (available used for good prices). Because BW negatives need enough exposure to illuminate the shadows, you might want to overexpose 1/2 to 1 stop from the average light reading. If you are ambitious enough to learn Ansel Adams' Zone System, you can use special chemical additions to your developer stage to extend this tonal range even beyond what your eye can see.

3. **Deciding.** What is the most important part of the scene or subject? In the tonal world of BW, you want to make your statement with shape and contrast. Is it a dramatic high-contrast situation or all soft grays, like a misty day with the promise of romance? There will be times when you allow the highlights to blow out for the sake of holding shadow detail and vice versa.

4. **Developing.** Do it yourself or get it to a knowledgeable lab. Please, no chain drugstores! There are many tutorials online to find good techniques. The film manufacturer will have chemical, time, and temperature recommendations for your starting point. I suggest sticking with one film type at first say, Ilford HP5 or Kodak Tri-X. They have a huge following, so there's a lot of info available, and both are forgiving films in case your technique is a little off. And that's the fun of doing it yourself. Make a mistake, experiment, keep a few notes, and you will find your own path to B&W fulfillment.

(continued)

Barry Kaplan on How to Develop Black-and-White Film at Home (continued)

Here are the basic steps to get started.

◆ Film: Tri-X 400

◆ Chemicals: Prepare these ahead of time and set them in front of you in the sink, ready to access as you go through the steps. Read and follow the package directions explicitly.

◆ Developer: Kodak XTOL or D-76 (powder mixes; both are excellent). XTOL may give you slightly finer grain. Ilford, Sprint, Agfa, and Edwal all make good products. T-Max liquid developer is also good and very convenient to mix.

◆ Stop bath: Water or glacial acetic acid (a concentrate that mixes with water to immediately stop the developer action inside the tank).

◆ Fixer: Usually mixed at one part fixer to three parts water from a liquid concentrate or a powder mix.

◆ Hypo clearing agent: This is required to eliminate any residual fixer from the film. I like Perma Wash by Heico. It cuts your water usage for washing down to two minutes, saving costs and the environment.

◆ Wetting agent: This helps water from the final wash step "sheet" off the film surface, allowing for even drying with no streaks. Don't over-concentrate the mix, as it can leave white residue on the dry film.

◆ Dryer space: A place to hang the wet film away from possible airborne dust is a must. If you don't have a drying cabinet or a broom closet, there are plastic ones for sale, or you might make one from an old-fashioned shoe bag hanger. I prefer to let the film just hang and air dry for a cleaner result.

◆ Small developing tank: Stainless-steel Nikkor-style or Paterson-style plastic. Each of these tanks has specific style reels for rolling the film onto them in complete darkness. The plastic reels are easier to learn but harder to keep clean. The plastic reels also adapt to handle 35mm or 120 film sizes. You need to practice reeling a length of film onto your reels with the lights on until you can do it with your eyes closed and cause no kinking or bending of the film.

◆ Film cassette, tank, reel, can opener, scissors.

Ready? Lights out! It should be dark enough that after two minutes you can't see any light leaks or your hand in front of your face.

1. Open the film can with the can opener and slide the film out. It may want to unroll, so keep a light grip on it and keep your hands over the work area in case you drop it. I've hit my head coming up from the floor in pitch dark so many times that I should wear a hardhat in the darkroom.

(continued)

Cut off about 2 inches of film below the leader, nice and straight across. This helps the film insert evenly into the reel. Sometimes a 36-exposure roll will have a leftover "tail" at the end of your loading. If this happens to you, either you didn't cut off enough leader or it slipped out of the center core of the reel. You could remove it and start over, but it's okay to leave an inch or two loose for your first time, although the frames on this part are subject to damage.

Now drop the loaded reel into the tank. If you're doing just one roll, add an empty reel to the tank to take up the rest of the space. This prevents over-agitation from too much movement in the development step. After you pop on the tank cover and its partner the fill cap, you can turn on the room lights.

2. As long as the caps are fitting tightly, your film is safe in the can with the lights on for as long as you need to mix and temper your developer. Because you have already made your stock solution of developer from the mix, read the directions and figure out whether you will further dilute it for use as a "working" solution or whether it's ready to use. Make enough to cover the reel or reels inside the tank at a measure of 8 ounces per reel. If you have an empty reel on top, just use 8 ounces for the one with film.

If it's a ready-to-use mix and it's too hot or too chilly, you can temper it by running water along the sides of the container before you add it to the tank. Some people in warm climates use ice to cool down solutions, but you have to allow for the increased dilution and extend your developing time. Your goal is to have 68- or 70-degree developer for the best contrast and grain. Use a thermometer to watch your temperature.

Using a small graduated or measuring beaker to temper your 8 ounces makes it easy to deal with the chemistry. Remove the small top filler cap, tilt the tank at an angle to help displace air, and pour the liquid into the tank at a steady rate. If you have two rolls to cover, you'll probably have a little chemical run back out of the top. Now replace the fill cap and rap the bottom edge of the tank on your sink or counter to dislodge air bubbles that entered along with the flow.

Then do your first agitation for 5 to 10 seconds and let it rest. (To agitate, pick up the tank and tilt it right and then left about three times in 10 seconds. Do this every minute of developing and fixing. With Perma Wash, you'll do it constantly during the one minute of that step.) You will repeat the steps of agitate, rap, and rest once a minute until the last minute of the development stage. With 15 seconds to go on the timer, remove the fill cap again and start pouring out the chemistry. (Developer is not harmful to the environment in this dilution, but I still wouldn't pour it into a septic system.)

3. As you empty the tank, this serves as your last agitation, and you can then stop the developer activity by filling and emptying the tank two to three times quickly with water of about the same temperature. A better way to stop developer activity, which is alkaline in nature, is to use stop bath—a glacial acetic (acidic) chemical that neutralizes the developer on contact without any other effect on the film.

The choice of which to use goes back to the idea of flexibility and personal results. I don't like the smell of stop bath and have learned to allow for the developing action to continue a little beyond my ideal time. However, if you are using a fixer that will be reused as part of a larger working solution, I'd use the stop bath to prevent weakening the fixer with leftover developer that remains after the water rinse.

(continued)

Barry Kaplan on How to Develop Black-and-White Film at Home (continued)

4. Now you have emptied out the developer, you've stopped the process with water or stop bath, and you are ready to fix the film. Fixer removes any remaining silver from the film that was not converted by developer. Without this step, your film would be ruined by exposure to light when you opened the tank. Use a hardening-type fixer and agitate as described in Step 2 for the two to four minutes required. After the film has been fixed for at least two minutes, if your anticipation gets the better of you, you may open the tank and inspect your handiwork. But put it back in and finish the full time. I feel that the full four minutes suggested by most film and chemical suppliers should be followed for permanent results.

5. Clean film lasts forever, as far as we know. The three washing steps will ensure that your film won't fade or develop staining over time from residual fixer. Remember, fixer's job is to remove silver from film, but we only want to remove unwanted silver, not the nice highlights we worked so hard to produce. A typical wash will be water for two minutes with constant agitation, Perma Wash or another hypo clearing agent for one to two minutes with agitation, and a final wash of about five minutes. Water is not a resource to be wasted, and the amount you need is less than you might guess. Kodak's recommendation is enough water to completely change the water in the tank once in five minutes—that's little more than a trickle for a small tank! Keep your wash water close to the same temperature as in the other steps.

6. Final rinse—sometimes called *wetting agent*—minimizes drying marks by helping water sheet off the film as it hangs. It's like Rain-X for film. The key here is to gently pour the mix into the open tank and give the reel an easy spin to make sure all the surfaces get coated. Do not agitate in this step. You don't want a bubble bath for your film. When you lift out the reel and remove the film, try to maintain one direction for the lift. If you lift one end and then reverse it, the resulting water streaks may show up as lines on your prints.

7. Hang the film up with a wire and alligator clip or clothespin at the top. You can hold the film straight by attaching a weight or the used film can to the bottom of the roll. Close off this space so that no dust dries into the emulsion and leave it for a couple of hours to dry. You'll know it's dry and ready to print or cut when the curl is convex and the base (non-glossy side) side is atop the curl.

Congratulations! You have the satisfaction and pride of working with some of the earth's basic elements to create a magical capture of light and shadow. You will become a better photographer by seeing the range of tones your film gathered. And you will make better decisions about how you want your prints to look, whether in your own darkroom or at the counter of your favorite photo lab.

Ingrid's Turn

Some of my favorite photography-school memories are the hours I spent in the darkroom, developing film and wet printing images. True, exposure to fumes and chemicals for extended periods of time might not be all that good for you, but it's funny how I associate that smell with a certain kind of creativity. We worked in well-ventilated spaces, and the odors associated with that time are forever etched in my fond recollections. Maybe it's the hands-on approach to a tactile object that gives film a different life than uploading straight files onto our hard drives. There is something to be said for making something concrete that you can touch. It becomes more than the idea, and the process and its many, many variables become an artistic journey with different possible outcomes.

Barry's step-by-step directions leave out the feelings associated with fumbling in the dark, trying to get your film onto a little metal reel. It takes some concentration. The splashing of chemicals, the smell, the physical exertion it takes to agitate, the experience of holding your negatives up to the light once they are fixed and washed for that first peek...

If you really want to call yourself a film shooter, then I think developing a roll of B&W film is an absolute must. At the very least, you will learn about the amazing chemical process that takes light and silver and makes a negative, which you can then print. It's nothing short of magic, in my mind.

7

Pushing Film

Film is organic in nature; it's composed of chemicals and is developed with more chemicals. Because it's chemically based, you can play with it and modify a given film's structure during development to squeeze more image quality or contrast for a given exposure. When you *push* a film, it sits longer in the developer than it would normally.

In layman's terms, this means that you can rate many films beyond their given box speed to get the desired exposure or look you want. If you have 400 speed film and need to shoot at 1600, you can rate the film in the camera at 1600 and then have your lab push the film two stops to increase the gamma curve of the film—that is, to pull more detail from the shorter exposure and increase contrast.

When I need to shoot a lot of events at around 1250 to 1600 ISO, I push my 400 film two stops to get to 1600 and my 800 film one stop. I could use flash (and I sometimes do), but pushing the film to a higher ISO gets me the results I need. The reason I push the film to 1600 is because no one in the U.S. makes 1600 film anymore. You can get some in Japan that's awesome, but here in the U.S., you need to push your film to get high ISO.

When I do push my film to 1600, I like to meter for 1250 and try to overexpose as much as I can while keeping my shutter speed as high as I can. Most professional and even good consumer film already has a high exposure latitude and can be shot at higher ISO without pushing in development. I can easily shoot Portra 400 at 800 or even 1600 and get amazing results without pushing. So why would I push? Pushing increases the contrast and raises the gamma (contrast density), or curves, of an image. So if I want to get more contrast and higher curves (the levels of density in the negative), I push my negatives. Pushing makes the image look less flat and more normal, as if that film is normally rated at the speed at which you shot it.

"If I want to get more contrast and higher curves, I push my negatives."

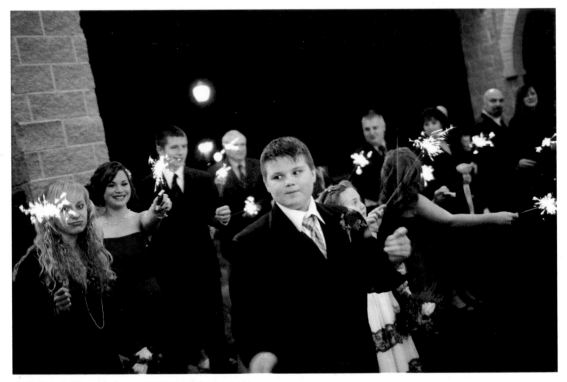

Images shot on Portra 400 at 1600, pushed.

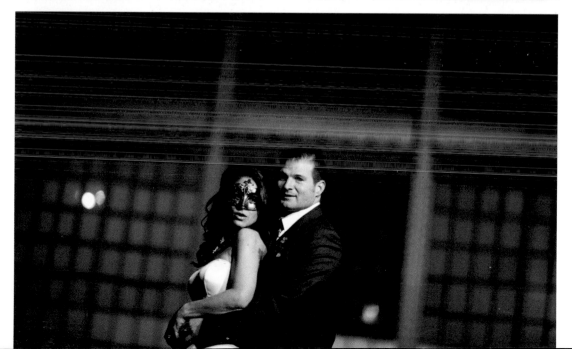

"It's amazing what you can get out of a BW negative."

Some films push better than others, and black-and-white film, such as Tri-X and HP5 Plus, push incredibly well at many stops. I have seen photographers easily push the film from 400 ISO to 3200. I like to shoot it at 1600, but I've even heard of people pushing it four stops. It's amazing what you can get out of a BW negative.

These images may be grainy, but I love the look, and I believe the grain adds character to the image and is a stark contrast to the ultra-clean digital photos photographers turn into BW images. It has real texture. My clients like it, too. It's not for everyone, but if you like gritty, real images, then this is the film for you.

Most of the events I shoot take place at night and in dark places. I don't get a lot of sunlight-filled events here in the city. So I have to push the film stocks I have to get the exposures I need. I will also use flash as needed—both bounced and direct. I love direct flash for dancing photos and introductions. It gives a very 1970s club look.

NOFEAR

Don't be afraid to use direct flash. You might be really surprised by how well it works with film!

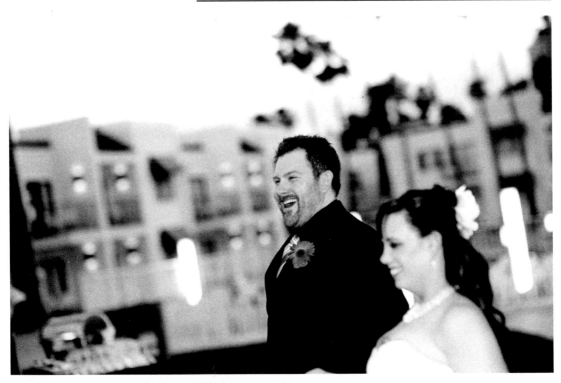

Images shot on Tri-X, pushed to 1600.

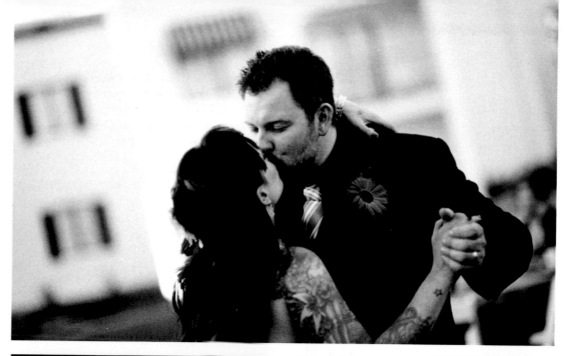

Every film looks different when pushed, and I highly recommend experimenting with your film stock to get a feel for how it will look when pushed. Some films will become very grainy, others will yield super contrast, and others will look the same as always, with just less shadow detail.

My favorite film to push for color is Portra 400, but I also like to push 800Z. Both are great, but they look totally different at 1600. I find the Portra tolerates tungsten light better, whereas the 800Z looks really warm and noir-like.

Images on this page were shot on Tri-X, pushed to 1600. Image on next page was shot on Fuji 800 Superia, pushed one stop to 1600.

In addition to pushing film, there is also *pulling* it—to shorten its development time. I've never done this, because I find that most modern color negative films look awesome overexposed, even at multiple stops. I can see why you might pull BW film, because it doesn't overexpose as well as color negative film, but I've never had to. BW film does not overexpose well; highlights and detail can easily be blown out. If you had, say, BW 400-speed film and shot it at 100, I would tell the lab to pull it to 100. The lab would leave it in the developer for a shorter period of time, and you wouldn't lose your highlight detail. And I would say the same for E6 films (slide film), because they don't have the exposure latitude that color negative films have. If you grossly overexpose a film, pulling it may save it.

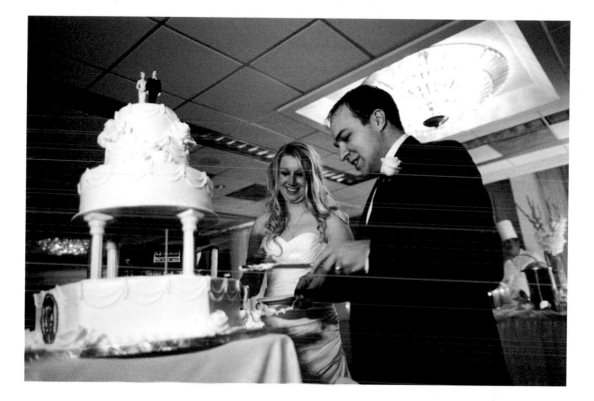

Ingrid's Turn

Pushing or pulling film is one way to really get to know your materials with the process of manipulation. I like to think of it as finding out what your medium is capable of. How far can you make this emulsion stretch? What happens when you do this? The simple act of testing limitations teaches you more about your materials and makes you more aware on an intuitive level. It creates *experience*. Through experience, you can become one with the technical aspects of photography and make your art. So my advice about pulling and pushing film is to *just do it*. You might unexpectedly find something you didn't think was possible, discover a certain grain quality that you like, or at the very least learn the limitations of your film-development combinations.

8 Movie Films for Still

Sometimes I don't want to shoot normal 35mm professional film. Sometimes I want more. I want cine film. Both Kodak and Fuji make professional color negative movie films that are tungsten (white-balanced to incandescent, based at 3200K like a normal indoor lightbulb) and daylight (white-balanced to the sun, at 5000K) based and have incredible exposure latitudes and color saturation. These are the films on which Hollywood films are shot. There is nothing better in the analog world.

Shooting movie film presents some problems for 35mm still shooters. First, it's only available in hundreds of feet. A normal 35mm cassette has five feet of film in it. So you need to do one of two things: You can get a 200-foot bulk loader (a daylight device into which you load film in a darkroom—but then you can use it in open daylight to load normal 35mm cartridges yourself), or you can get a camera with a bulk back, such as a Nikon F3 with an MD4, and shoot 250-exposure rolls that need to be loaded in the dark. I have tried both methods, and neither is super easy; I always feel as if I'm going to mess up something! In reality I haven't, but the room for error is marginal.

Shooting bulk film was the answer to shooting long events without needing to change rolls of film often. Today it's a hassle— I have to load the film in a completely dark bathroom. Plus, not many labs can process the 30-foot rolls of film that bulk cartridges take.

There are still many photographers shooting on bulk film backs. The Brothers Wright use the same setup as me and are the reason why I got into shooting bulk film. There are Canon and Olympus versions of bulk packs as well.

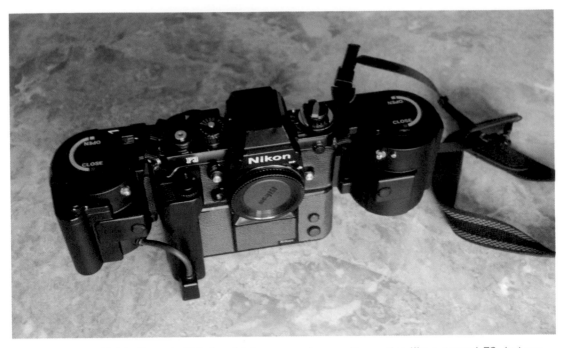

My F3 with the 250 bulk pack. This is a tricky camera to use. It operates like a normal F3, but you have to be sure all the knobs are in the right direction and that the film canisters are loaded and positioned properly. A mistake can cause you to end up with scratched film—or, even worse, the film won't take up on the take-up reel, and you won't be shooting your film. If you're not paying attention to the take-up reel spinning, showing that the film is spooling and being taken up, you're in trouble. Each cassette holds 250 shots, or about 30 feet of film, and is wound into another empty cassette. I like to fire about 20 shots at the beginning and end of each roll, just in case the ends get damaged at the movie lab or exposed to light.

Developing ECN2 Film

The next problem is getting the film processed. Not a lot of movie labs are willing to process short lengths of 35mm, because their machines are set up to do 400-foot rolls (or greater), not rolls under 100 feet. There are a few labs, such as the ECN-2 lab (www.ECN-2.com) in California, that will process it by hand for you and sell you the film loaded into 35mm cartridges—they're your best bet. You can't take it to a normal photo lab to process in C41 chemistry, because the film is made to be processed under a different chemical mixture and process called *ECN2*. The film is also coated with a chemical to keep it static-free in high-speed cameras; this is removed first in normal ECN2 processing but would gunk up on the negative in a normal C41 process.

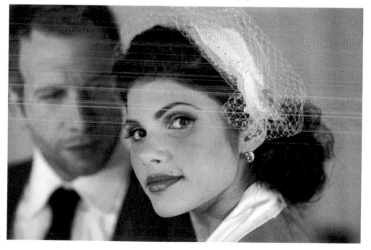

Images shot on Kodak 500T, pushed two stops to 2000.

I love shooting cine film for two great reasons. First, its exposure latitude is insane, and I can easily push Kodak 500T to ISO 2000 and get almost grainless images with great contrast and color. Second, the films are available in tungsten, so I can shoot tungsten-lit receptions and not worry about people looking orange.

The slower-speed daylight films are just as amazing as the high-speed films, giving negatives that are smooth and great for scanning. I love Kodak 250D for its ultra-realistic tones and detail from highlight to shadow. I have not seen another 35mm still film come close to its quality

"The slower-speed daylight films are just as amazing as the high-speed films."

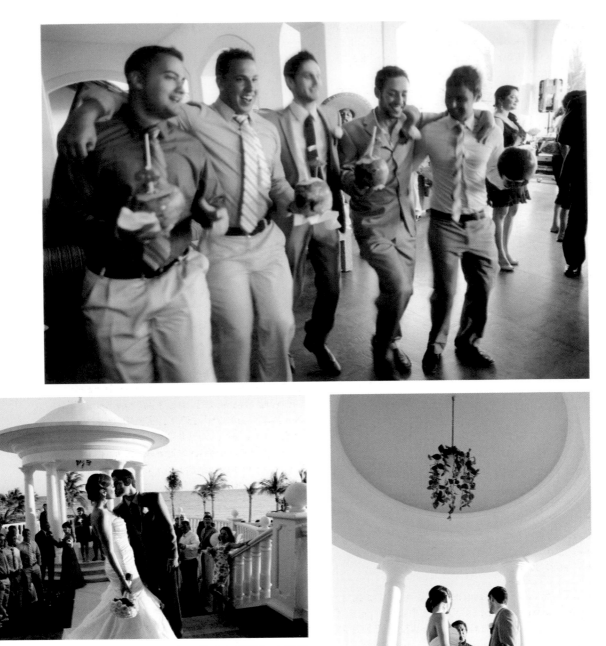

Images shot on Kodak 250D at 200.

Note that when shooting tungsten movie film outside during the day, you need to use an 85B filter to compensate for the blue daylight; otherwise, your images will come out blue. The filter is orange and warms the blue daylight to the correct white balance for the film. You can also do this in post, but it's easier to do it while shooting so you don't have to Photoshop and color-correct all your shots afterwards.

In the past, I had to deal with the headache of buying and loading cine film for still use, but now I don't have to. Movie film is awesome. There is nothing else that compares to its latitude and color rendition. Up until now, it has been hard to shoot, but now that the ECN-2 lab is up and running, you can buy it from them, and they will process, develop, and scan it for you.

NOFEAR

Be patient and wait. Don't just blast photos away. Remember, you only have 36 shots to a roll. Make them count!

If you want to be brave and go to a non-pro lab, you can take movie film and process it at your local minilab. Just load it into normal 35mm cassettes and don't tell them it's movie film. I don't recommend doing this to a lab you like or to a pro lab, as the rem jet on the film can gunk up their machines, and rolls processed after yours may have spots on them. If you want to try it at a drugstore one-hour processing place, you should be fine—but the next guy's roll may be a bit spotty.

In case you're wondering, rem jet is a carbon coating on the base side of ECN2 film that is supposed to protect it against static buildup when it's being used in movie cameras and moving really fast. This rem jet has to be removed for you to scan or print the film. When you develop the film, it will come off and leave a sticky, gunky black mess. If you don't clean it correctly, it can ruin your negatives and make a mess. And if you run it through a C41 mini lab machine, particles of it will come off and stick to parts in the machine and possibly onto the rolls.

Doing this will result in the lab thinking your film has gone bad or has not come out, because the negatives will come out of the processor covered in the black rem-jet coating. But all you have to do is wipe it off with a sponge, and you'll have good negatives. The problem with the C41 process, though, is that the chemistry is not the same as in the ECN2 process. The colors and contrast will not be perfect, as they would if the film was processed normally with ECN2 chemistry.

The other viable option is to hand-develop your ECN2 film in C41 chemistry in your sink or darkroom. Developing color film is very much like hand-developing black-and-white film, except that the temperatures are much higher—the developer has to be at 103 degrees. I have been having my lab hand-develop my ECN2 film for a while, and it comes out awesome. I haven't had any issues; I've been shooting Kodak 250D and 500T and having the 500T pushed a stop. It's an easy process—the only step that is different than developing BW is that you have to wash the rem jet coating off the film before you stabilize it. So far, I've been doing this with a sponge and a water jet, but I really need a good film-scrubber washer, and that will have to be built for it to be done right. The rem jet does come off easily, but you have to make sure you get it all, or it will become hard after the stabilizer, and then it's more difficult to remove.

If you want to do this at home, there are plenty of C41 at-home kits available at most pro camera stores or websites. Check out BH, Adorama, Hunt's, and Freestyle Photo for an at-home color kit, or just send your film to the ECN-2 lab.

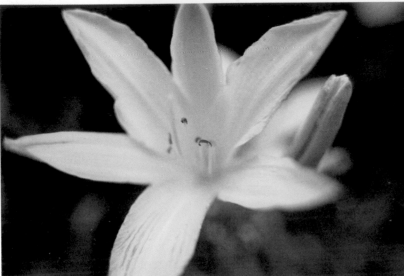

*Examples of 500T
and 250D developed
in C41.*

ECN2 films from Kodak and Fuji, such as 500T, are really the only viable solutions to shooting high ISO color film in low light. The results are much better than shooting 400-speed or 800-speed C41 film and pushing it in tungsten light. These films are also designed to be scanned, whereas C41 film is meant to be printed optically. Try some, and you'll see the difference.

Your options for shooting and developing these films are getting better. You can do it all yourself with a bulk loader, you can buy it prepackaged with developing and scanning from www.ecn-2.com, or you can shoot it in bulk lengths and find a movie lab to develop it. I personally think the ECN-2 lab (www.ecn-2.com) is your best bet—or developing it yourself.

Shooting 500T

Shooting 500T is not all that different from shooting normal C41 films, but there are a few things to keep in mind about it.

As mentioned previously, it is a tungsten-based film, made for tungsten light, not daylight. If you shoot it in daylight, your images will have a blue tint. You can correct most of this in scanning or post-production, but you cannot fix it 100 percent. If you're going to shoot in straight daylight with it, it's best to use an 85B filter or a warming gel to correct for the blue cast. If you're shooting in mixed light or full tungsten, then you're fine without a gel or filter.

NOFEAR

Don't be afraid to ask others for help. Join a film-users group online and discuss your problems or successes. There's no better way to learn!

Also, at box (or rather, can) speed, this film is 500 in tungsten and 320 in daylight with a gel. That's box speed—and at that, you are really overexposing a bit. This film is truer to being an ISO 800 (the box speed should be 800, but the film looks better overexposed at 500) film than a 500, but that's due to the high latitude and dynamic range it has. You can easily shoot this film at 800 or 1000 without any pushing and get good results. It does depend on the lighting, though. I always try to overexpose this film. If my meter tells me to shoot at 1/60 at f/2, I'll shoot at f/1.8 or f/1.4—the more light, the better.

If I want to push the film, I can shoot it at 1600 and 2000 without any issues. I usually only ask for a one-stop push in development when I rate it at 1600. For 2000 or 3200, I will ask for a two-stop push. Depending on the light, you may want a two-stop push, but it will depend on how your lighting was and whether you were able to overexpose. If you rate it at 2000, try to overexpose when you can and shoot more like it was 1600; otherwise, shadow detail will be gone.

If you're shooting 500T at a wedding, and there is a video guy shooting with a bright video light, make sure he's using it set to tungsten. If he's shooting with daylight-balanced LCD, it will create a blue cast on your subjects, so ask him to gel his light or change its white balance. I always bring gels with me so that I can match color temp on my flashes, too. If I decide to use flash I make sure to gel it—I don't want a funky blue cast on my images.

9 Ingrid's Turn: Prints

Ah, prints. Do we really even have a photograph without a print? Some may argue no. The printing process is the final step in creating a photograph, and along with the variables of exposure and development in a negative, you have a similar set of rules in the printer's darkroom. Printing is just as integral a part of photography as taking images. You have to understand basic concepts such as exposing the paper correctly and then developing the latent image for the correct amount of time. The printing process can enhance or hinder the final outcome of your vision. If you choose to do your own printing, you will have the most control as you complete the steps it takes to make a print. Some people entrust the printing to a lab instead. Either way, in the next few pages you will discover some of your *many* options. Your choices are what make the art. The final step is the creation of a tangible work: a photo.

I find that the experience of looking at an image on a screen is different from looking at it on a wall or in someone's hand. I like things tactile and concrete, so a print feels more real to me. Some of my favorite childhood memories are of looking through old family photo albums of birthdays, long-past vacations, and deceased grandparents. When the analog camera was the norm for an American family, rolls of film were dropped off at photo-development places, and happy customers would exit with envelopes of 36 glossy images. The images weren't always in focus, they weren't always exposed right, and they weren't perfect, but they were a reflection of the time. They ended up in shoeboxes, on refrigerator doors, and in our tangible world.

The problem I have with digital is that many images aren't getting printed. Whole histories are being stored on digital drives (which aren't always backed up). The images that *are* printed (those lucky few) are typically the perfect ones, where everyone is pretty and pressed and smiling. Where are the outtake photos that we all know and love?!

I was at a friend's house the other day, and she had a frame with a running slideshow of images, one after the other. For some reason, the automatic three seconds for which I got to look at each image bothered me. I associated the moving slideshow with the flicker of a TV changing channels. There was no way to slow down, to pause and reflect, or to hold or relive. It was almost as if the past memory was somehow flipped into the current rush of daily life. Instead of bringing me back to a time and place, the sequential motion tricked me into the present. My friend loves the fact that this device takes up little room and stores thousands of images—and I get that. We live in a modern world. My analog heart just doesn't feel it in quite the same way. I feel that photography is the art and science of stopping time, and I think holding a static print reinforces that singular moment.

This image isn't perfect by any means, but it captures a very real snapshot in time!

As a wedding shooter, I have a lab do most of my printing for me. Most of my prints are done from film scans now, as opposed to the traditional style C prints, or wet prints, that I would create when doing my own printing. Prints are easy and fairly cheap to make through a professional or consumer lab. You have a large selection of surfaces to choose from, including matte, glossy, metallic, canvas, watercolor, and rag. I have even made prints and mounted them to wood.

Prints mounted to wooden blocks.

You can have your images made into albums or matted for framing. However you print and make the image into a tactile thing, that is when it truly becomes a *photograph*.

Albums and matted prints.

The traditional printing process itself is not much different from the exposure and development of the negative. In the technical sense, you have light-sensitive paper, exposed to light through an enlarger and then developed in a chemical process. Each step affects the final result, just as it does with a negative. The labs use machines that expose traditional photographic paper using lasers and then run it through a modified RA-4 developer. Giclée-style prints are done with archival-quality inks sprayed onto paper, with no developer and no exposing with light.

Different Common Print Types

There are a number of different common print types.

◆ **Fiber-based B&W prints.** These silver-based paper prints come in many textures and tones. Used in gallery exhibits and known for their archival quality, FB prints are considered among the highest-quality prints you can make. They cannot be run though a machine like their less costly RC cousins. Fiber prints need to be "wet" printed in developing trays. B&W chemicals are needed to bring the image to life. Many fine artists who like to tint, tone, or hand-color their images use fiber-based prints.

◆ **Platinum print.** This print type differs from a traditional silver-based print because instead of the metal being mixed into a gelatin, the platinum lies on top of the paper surface. This results in a matte finish with unparalleled tonal range.

◆ **RC B&W print.** RC is short for *resin-coated*. This is also a silver-based print, but with more of a plastic feel. These papers are more affordable and can be run through B&W printing machines. The glossy option on an RC print is very glossy.

◆ **Traditional C print.** A traditional C print is made using a color enlarger and a negative, which is then run through chromogenic materials and process. The dye layers (cyan, magenta, and yellow) go through a chemical reaction that creates the full-color image.

◆ **Digital version C print.** This is the same as a traditional C print in the process, but the paper is exposed with an LED. A digital scan is done from the film negative, bringing the hybrid workflow into play. These prints are also known as *LightJet* prints. Both paper types are silver halide–based and the silver reacting with the dye layers in chemistry results in the color image.

Still Life with Toy Alligator.
2011.

◆ **Giclée print.** This type of print is made using an inkjet printer. There is no silver halide in this process. The images are made using archival and fade-resistant dyes that are sprayed onto the paper of choice. This option opens up a whole array of different surfaces to print on, which can be exciting to the artist. This type of print is made from a digital file and is one plus to a hybrid workflow between the analog and digital world.

◆ **Wet-plate print.** Before photographic paper or film was invented, photographers used to put their images onto glass or tin plates. Because the chemicals are fairly toxic and the process is labor intensive, it's not a very common way to make images now. You start with a piece of glass or tin that is cleaned and coated and then pour a sticky emulsion onto the surface, set it into a silver-sensitive solution, and place the wet plate into a negative carrier. Within 10 minutes, you must take the image and develop it to achieve an image on the tin or glass itself.

So how do you choose? You have your negative or your film scan—now what? I almost always see my images as a finished product before I begin shooting; it's part of my conceptual process. For example, when I'm shooting something like a wedding, I know that the set of images tells the story. Typically, I will include about 600 prints, all in a small 4×6 size, in my wedding packages. I like to have the lab include a white border around the edges to create an instant frame. It feels a little more vintage, and I like that look for a wedding. This set will include portraits, detail shots, candid photos, and even landscapes. The prints become the story.

I choose to print them as digital C prints because that is the most affordable option, and it makes sense when printing in large quantities. I'm not saying that you couldn't pick 10 images from a wedding day and do that set on fiber paper, mat

them, and frame them—you could! But the look and feel of both options would be very different. A small set of handcrafted prints will feel more precious and would likely be very select images from the day: heirloom photographs. The set of 600 would more likely be flipped through, handled, gifted, and pinned to the office wall. So, when you go into a lab with your images, ask yourself, "What do I want the end result to be?"

Some labs may offer traditional C prints along with the digital versions, but you should expect to pay more. Most images that I have done for my wedding work are digital version C prints, and both the color and black and white images are done on color paper, with the B&W images printed to neutral. A few labs have machines that can do digital prints on true silver-based black-and-white paper.

As a portrait and wedding shooter, I get prints done in bulk (proofs), and because of cost, the most affordable option for me is the machine-run digital C prints. These machines scan the negatives into digital files and then use LED lights to expose the paper. All my images, both B&W and color, are scanned in and then printed on the same paper for a consistent look (which goes through the chromogenic chemicals). I like my B&W images printed to look neutral, but you could also use a little red and yellow shift to get a sepia look.

I also do fine-art projects on the side. I just finished a project involving 4×4 tiles of trees that I now intend to print out on 3.5 feet of metallic paper. So the brightly colored images and the grid I created needed to be big to achieve my end result. I did a series of trees that I had printed onto watercolor paper, and the prints were only 1.5×2 inches. For me, the size of the print and the contrast of the subject (trees are normally so big) created a statement about the work just by *choosing* the print size.

Let's Make a Print

Okay, now let's make a print—either yourself or through a lab. There are a few things to consider:

◆ **Size.** With a large inkjet printer, you can now make prints of gigantic proportions. You can also make tiny prints and everything in between. There are quite a few "standard" print sizes relative to the dimensions of film negatives. A 4×6 print is proportional to a 35mm negative, for example. Most frame shops are stocked with these standard sizes, too, making it easy to pop an image behind some glass and call it a day. Besides the normal 5×7, 8×10, and 11×14 dimensions, you can crop your image square, long and skinny, wall size, or packet size. The first step is to figure out what you want to do with the print and then make your size choice.

◆ **Paper type.** I mentioned a few different print types earlier, and in each of those categories are subcategories. Fiber-based paper comes in glossy or matte, as does RC paper. There are different brands of photographic paper: Kodak, Fuji Crystal Archive, and Ilford, to name a few. Epson makes some beautiful papers for inkjet prints. Each of these will give different contrast levels, surface textures, and color or tonal ranges. The best thing to do is look at the paper swatches at your local lab and decide which you like best.

◆ **Printing.** If you are having someone print your images for you, you might tell them how you like your tones and highlights to look. Are you someone who likes a soft high-key look, or do you like punchy contrast? My biggest pet peeve is when the printer "over prints" my images, and the skin tones get too dark. You really have to communicate with your printer and create a profile to get the best results from your lab. If you're doing your own prints in a home darkroom or on an inkjet, you will be able to tweak the settings or exposure until you get it right. The look is entirely subjective.

Although we don't go into detail on darkroom printing in this book, when I was in photography school, the darkroom was my favorite place to be. The anticipation after shooting—bringing the negatives to life in a little silver canister and then seeing the print appear under a glowing red light—was the ultimate high, the magical moment. Being in the darkroom, with its chemical smells and water running over your hands, is a very different world from sitting in front of a computer screen using Photoshop. There is nothing quite as beautiful as a true silver-fiber-based print. The tonal quality you get is unmatched. But, I realize that in today's world, the hybrid workflow makes certain things much easier.

One aspect to the hybrid workflow and printing is that retouching, burning, and dodging (which can be quite a challenge in the darkroom) are made simple at a computer desk. I like the flexibility of prepping image files to print on the computer. You can take the film scans and alter them, just as a traditional master printer would. You might increase the highlights or burn the corners down to focus on one part of an image. You can desaturate a color image or apply sepia tone to a black-and-white shot with a finger stroke or a few keys (as opposed to putting on gloves and messing with toner).

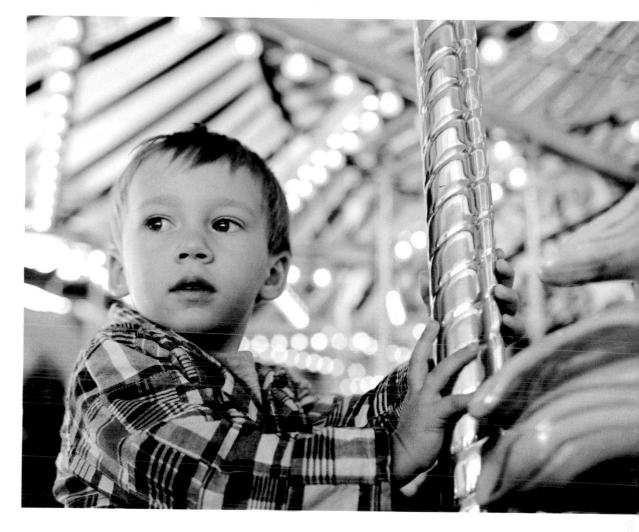

Ultimately, I feel that if you aren't printing your images, you really don't have a photograph. You may have an image, but not a true photo. The most important aspect I'd like you to leave this chapter with is that the end result comes from your personal choices —so choose. Choose to print.

10 Weddings on Film

Weddings: They are my life and passion. Photographing the most important day in a couple's life is no easy task, and it's not for the faint-hearted. Weddings are exciting—full of little and big moments and pure, raw emotion. My goal is to capture that emotion and record the events of the day. I choose to do this on film.

A Little Background

My first camera was a film camera. I learned on film, ate it up, and fell in love with it. This was way before digital was in any way affordable. I got into weddings simply by being asked to shoot them. One day in high school, I was called to the vice-principal's office. I thought I was going to get detention or something, but instead he asked whether I would shoot his son's wedding. He had seen my work in the local newspapers, as well as what I was doing in photography club, and he wanted me to photograph his son's big day. So I said I would.

That was my first wedding. I shot it all on film with a Canon Elan II and a Rebel G, using my Vivitar flash. I actually don't remember a lot from the day, but I do know they loved the photos. After that, I shot one more wedding on film before making the jump to digital (along with everyone at the newspaper office). I still shot some film, but not a lot—mostly personal projects. I didn't start shooting weddings full time until 2006, and I was all digital at that point.

I shot a *lot* of weddings, and all the time I was trying to make my photos look like film in Photoshop. Why didn't I just take the blue pill and stay with film? I guess I was caught up in the digital hoopla, like most photographers, and was listening to all the sales reps instead of my heart.

Fast-forward to 2009, when Kodak launched some new films—Ektar 100, soon to be followed by new Portra films. I picked up a Lomo camera and started shooting rolls of color and black-and-white film at my weddings. Then I got an XPan

and started shooting more film. Soon I ordered a Canon 1N and a Canon 1V and was shooting all film. My digital camera was just sitting in my bag. So I sold it. I sold all my digital gear and went 100 percent film by 2010. It was quite freeing.

No longer was I stuck looking at my LCD screen after every photo or forced to Photoshop the images to make them pretty, film-like, or even black and white. I do everything in the camera. If I want black and white, I shoot the BW film I want. If I want saturated color, I shoot Ektar. If I want great latitude indoors, I shoot Portra 400 or Fuji Superia 400. There is a film for everything.

And skin tones are awesome. I don't have to smooth my brides' faces with Photoshop brushes anymore. I make them look pretty in camera. Film just gives skin a smooth look, and if I overexpose a little, I can burn out any harshness on a person's skin and get a pastel look.

NO FEAR

Always shoot with more than one body if it's a major gig. A lab can ruin a roll of film. It's very unlikely, but I always take a few backup shots on a second body and roll of film, just in case.

With that said, I don't recommend going out and shooting a wedding on film unless you have a good knowledge of what you're doing. You need to know your gear, its limits, and what film you'll be using. There are no second chances at a wedding. Once a moment is over, it's over. Shooting weddings on film is easier than shooting digital, yes— *if* you know what you're doing.

"I shot a lot *of weddings, and all the time I was trying to make my photos look like film in Photoshop."*

How I Shoot a Wedding on Film

Here's what I bring to a wedding, plus or minus some gear depending on the wedding location and lighting scenario:

◆ Two Nikon F5s.

◆ A Nikon F3 with a bulk 250 back (I use this only when I need to shoot high-speed movie film)

◆ An XPan

◆ A Horizon Perfekt Lomo camera

◆ A Canonet QL17

◆ Three Nikon Speedlights

◆ PocketWizards

◆ An 85mm 1.4 D lens

◆ A 28mm 1.8 Sigma D lens

◆ A 50mm 1.8 D lens

◆ A Pentax 645 with 220 and 120 backs

◆ A 75mm f/2.8 SMC lens

◆ A Sekonic light meter

◆ Various video lights and colored gels

"There are no second chances at a wedding."

I typically shoot with one F5 on each shoulder—one fitted with the 85mm lens and the other with the 28mm lens. I sometimes load each with a different film, but sometimes I use the same film to make things easier. In my pockets I keep film, a light meter, and a lens cloth. Sometimes I keep a third fun camera around my neck, such as the XPan or Lomo Horizon.

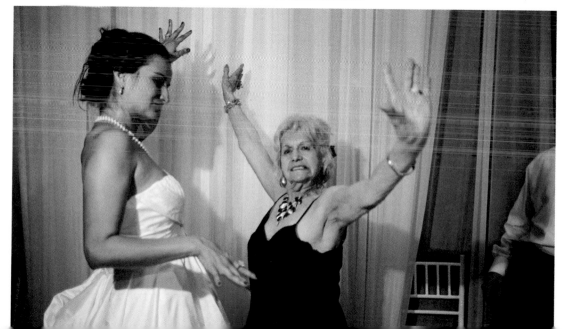

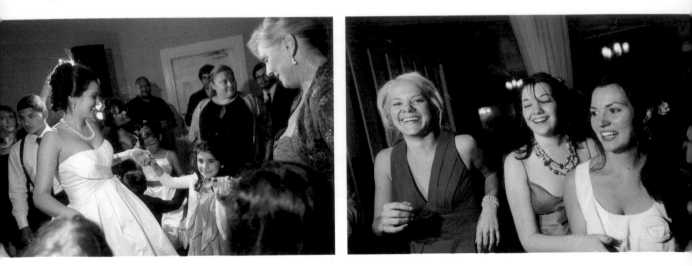

For the most part, I use my Sekonic light meter to get the lighting and expo-
sures done for a room, but I rely on the great spot- and matrix-metering
modes in the F5s once I know how they are reading the light of the room
based on the Sekonic readings. Or sometimes when I can't pre-meter a
room, I let the F5 do all the metering for me, and I spot-meter for the shad-
ows with color negative film and for the highlights with BW film. I do use
matrix metering and matrix fill flash as well when the action calls for it.

For flash at a wedding, I use manual metering and manual flash output. This
might seem difficult, but it's not. Just try it first. I set the power up and down
on my flash, telling it what ISO I am shooting and what f-stop I've set, and
the flash reads out the distance for the given exposure. I usually check this
with my Sekonic light meter. In general, my SB80DX flash set to 1/64 power
with Fuji 400 film loaded lets me shoot my 28mm lens at f/2 with people
three to five feet from me. This is how I shoot dancing at a wedding.

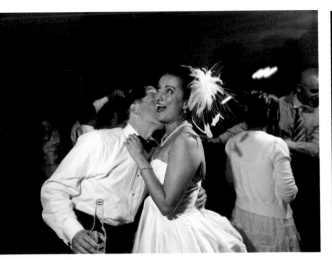

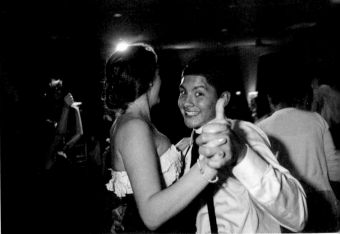

When people are moving toward me or for fast-action shots, I set the flash to TTL mode and dial in the power compensation setting—usually −1 for direct and +1 for bounced. The great thing with flash on film is that even if you pump out too much power, you'll still get a great image. Overexposing film is fine—you won't lose anything. This is in contrast to digital, where flash has to be perfect or you'll clip out or lose the highlights.

I love to shoot the reception in black and white. I just love the way it makes a wedding look. Most of my weddings are in older, relatively dark Boston hotels, so shooting BW works well in that it creates a timeless look. BW also eliminates the need to balance for the wacky up-lighting that is all the rage right now. At many weddings, the room is lit in all purples; BW makes people look normal, not like Smurfs! I like to shoot mostly HP5 Plus or Tri-X film at 1600 for the reception, with a few rolls of Delta 3200 for some mood shots. With BW, be sure to spot meter and expose correctly, because it has slightly less tolerance than color negatives.

> "The great thing with flash on film is that even if you pump out too much power, you'll still get a great image."

I like to shoot receptions in black and white.

For portraits, I generally like to pull out my Pentax 645 and get really detailed and amazing shots. The 645 format allows me to get larger images with a different perspective than 35mm. Just holding the 645 camera and viewing through it is a different ballgame than using the 35mm. You will start to see things differently and hence shoot in a different style. I like to open my lens, shoot really wide open, and get shots that are all about the couple. That's what I look for when shooting 645—I look for the real people.

For general coverage and action shots, I use my F5 with autofocus. Trying to keep up with all the fast movements at a wedding in manual focus or 645 doesn't work for me. My personal style doesn't allow for it, but I do recommend trying it—perhaps it will be a good fit for you. You can use 645 or 6×6 to photograph receptions and wedding action; you just need practice. I happen to like autofocus and all the high-tech features of my F5 too much to shoot medium format all day. I can also load 35mm faster, and I have more 35mm gear than 645 gear, so it works for me. But how you want to shoot is up to you.

Portrait shots taken with my 645.

I use 35mm for general coverage and action shots.

Family group shots are something that I find very important. Most families don't get together very often, so getting good group shots to create lasting memories is something I take pride in. But not every venue or wedding has a glorious view or grassy fields to use as a backdrop. Sometimes I just get a room with a window or curtain, and I have to make that work. For this, I try to use a 50mm or an 85mm lens for smaller groups and the 28mm lens for larger groups.

I like to load 100 or 160 film and then add flash if needed to light the group. I carry my studio strobes to many weddings, particularly when I know there will be a lot of large group shots that need to be lit.

I try to shoot at least f/2.8. I don't want people to be blurry, but sometimes I have to shoot wide open, so I try to get everyone on the same focal plane as much as possible. If I'm shooting outdoors, it's easy, but when I'm in a dark hotel, I

Family group shots—some done in hotel lobbies and some done outdoors, but all worthy of being printed and placed on a desk or wall.

sometimes need to rearrange a room to get the angles I want. By the way, don't be afraid to move things around if the light is better in one area than another. People won't remember you making a mess, but they will remember if you don't get them a shot with their grandmother. The light meter comes in very handy for group shots—meter for the shadows and shoot.

Shooting the details of a wedding is pretty simple, too. I usually load 400-speed Superia film in the camera, switch to center-weighted metering, and shoot. I like to use my 28mm lens because it has a macro setting, so I can take really detailed shots. I also like to use my 85mm or 200mm to capture images that show the room in depth and compress it. A wide-angle table shot is not as nice to me as a shot of the tables taken from farther away with the 85mm or 200mm.

You have a lot of flexibility with how you can take detail shots.

"Be sure to photograph the dress both in detail and in full length."

When I shoot a bride's dress—in color or BW—I use center-weighted metering and then overexpose one stop. If I don't overexpose one stop, the camera will try to make the dress gray in the image, so I need to compensate. Shooting the dress can be fun, because most dresses have unique and well-crafted details. Be sure to photograph the dress both in detail and in full length.

A bride's dress is extremely important to the story of her wedding day—don't forget to shoot it. I usually move the dress to where I think it will look best if it's not already hanging. Sometimes I find the dress hanging in a closet in the bag it came in. In these cases, I ask permission before moving it. Dresses can cost thousands of dollars, so you should always take care and precaution.

I talk a lot about taking meter readings, and I want to be sure you know how I do this. How you use your light meter and how you hold it can drastically affect your exposure readouts. I hold the meter in hand and set it for the ISO I want to meter. For example, if I'm shooting Portra 400 outside in shade or open light, I like to shoot it at 200, so I set the light meter at 200. Next, I make sure the bulb is full out. I then stand in the direction I'm shooting, hold it about 45 degrees down, and take a reading. I take three or four readings and then get the average exposure I want to use. If I'm metering for a shaft of light or direct sunlight, then I hold the meter up and let the light hit it directly. I don't want people in my shots to get raccoon eyes, so I meter for the shadow by holding the meter slightly down. This allows me to overexpose a little and get great shadow detail.

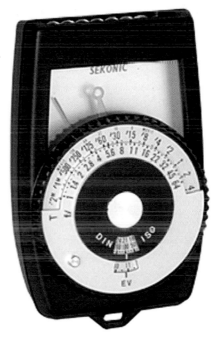

The best thing to do is experiment. Get the film you want to use, get out your light meter, and see how it reacts to the different ways you meter.

A light meter.

Ingrid's Turn: How I Shoot a Wedding on Film

Joe works a little differently from me at a wedding. Here's my bag of goodies:

- Four Canon EOS-3 bodies
- A Diana Mini
- Two Canon flashes
- Little softbox for flash
- Flash bracket
- A 17–35mm EF Canon lens
- A 100mm macro Canon lens
- A 35–70mm EF Canon lens
- A 70–200mm Canon EF lens with IS
- A Sekonic 508 light meter
- Extra batteries
- A tripod
- Mints
- Maybe my Mamiya RZ if the client requests it and pays extra
- Maybe my Fuji Instax if the client requests it and pays extra

All my camera gear fits into one rolling bag. I keep a little black bag on me with film and an extra 2CR5 battery.

I shoot with one camera on each arm. One has black-and-white film, and the other has color. I normally *only* shoot Portra 400 or Fuji NPH 400 along with Kodak BW400CN. I rate the film the same all day. I never have to think about changing exposure; I keep my film rated at about 200 all day and into the evening. When I need more light, I use a tripod and a slower shutter speed.

I use flash only when I have to: in dark churches during the processional and recessional and during the reception for dancing, cake, and toasts if there isn't enough available light. I only use on-camera flash. One light, and I rarely bounce. I like the paparazzi look of pop flash and think it creates a nice feel for nighttime party shots. I tend to shoot more black-and-white film with my flash and leave my color film for ambient tripod scenic shots of the reception.

I like to keep my equipment and process as simple as possible on the wedding day. That way, I can just let my intuitive side take over and be the watcher and journalist, which allows me to create the images I like for my clients. I rarely use medium format for weddings because it slows me down too much. I love the way it looks, but it doesn't fit well with my approach.

As a wedding photographer, you need to have a wide range of photographic abilities. You need to understand portraiture, editorial, and journalistic approaches, as well as have a talent for food, still lifes, and fast motion. Light changes constantly at a wedding, which is one reason why film's wide latitude is extra security, in case you don't expose perfectly. I'm fairly quick at switching the settings on my camera when a bride walks from shade into full sun, but there are times when it doesn't happen. Color negative film seems to make that four-stop difference okay, at least when you're overexposing.

Lomo at a Wedding

In addition to getting all the normal coverage of a wedding, I like to put down the F5 and Pentax and shoot with my Lomo or Canonet to get more vintage, less perfect shots of the wedding. Using a less-than-stellar lens and camera can yield images that contain lots of power and emotion. Shots don't need to be perfect all the time. I sometimes prefer the less sharp, slightly out-of-focus shots from my Canonet over my F5 shots. Giving a unique look to your work is very important, so don't be afraid to try new things. I stress the word "try," because you should always try things before putting them into play at a wedding. Get the kinks out first.

My Lomo camera captures great vista shots and creates a cool curvature all its own. Know your gear—learn it inside and out, and with enough practice, the tech part of using the gear will become second nature so that all you'll be concerned with is looking for the next moment or shot.

"Shots don't need to be perfect all the time."

Some Canonet QL17 and Horizon Perfekt shots at weddings. These shots aren't perfect, but I love them.

You don't have to shoot with a state-of-the-art camera at a wedding. Sometimes the look you get from a toy or an older, not-as-sharp camera can be just as good. You don't always have to shoot the best film, either. Film is divided into pro and consumer types, but that doesn't mean you have to shoot all pro film at a wedding. I love the look I get from some consumer films, and sometimes shooting pro film won't get me the look I want.

I also like to cross-process film and shoot it in a Holga or one of my Lomo cameras, such as my Horizon, and get totally wacky and different views of what I'm photographing. No one else with a digital camera will get the same look as I will if I shoot some expired slide film and develop it as C41. I'll have a really surreal and unique look that no one else will capture. Just try it.

NOFEAR

Try expired film. You may be able to get good deals on it. Just keep it refrigerated and try it out on an unpaid gig before you use it for something important.

For the record, I wouldn't shoot an entire wedding this way, but I love to shoot a few rolls here and there to get something different—something that will stand out and make people wonder how I shot it. Of course, there are plenty of Photoshop filters that can give you the same look, but I'd rather just do it in camera.

I like to get some cross-processed shots, too, for a unique look.

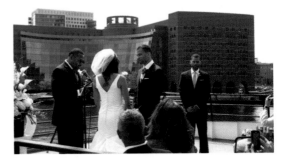

Expired Film

Many camera stores will sell expired film at discount rate. This film is usually a few months or a few years old. Most film is fine for a few years after it has expired if it was well cared for—that is, not left in the heat or left to rot in high humidity. If you buy some, just shoot a test roll or two and see how it looks. You may need to overexpose it to compensate for the film's age, but other than that, it should be fine.

Video Light at a Wedding

I love using video lights at a wedding to add flavor or just to add light to a scene. Many weddings take place at night, and sometimes ISO 3200 isn't enough. For locations such as these, I pull out three video lights that I have with me at all events. I have two types: tungsten and LED daylight.

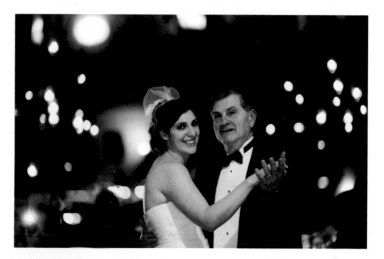

I use the tungsten Sunpak lights when I'm shooting BW film or tungsten movie film, or sometimes just to warm up a cool colored scene. These lights are great, and they spotlight perfectly.

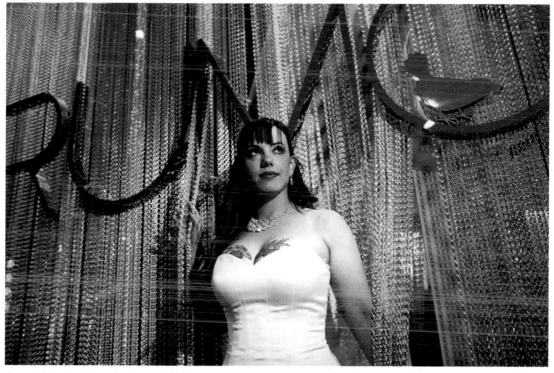

Images shot using my Sunpak lights.

My LED lights are my new favorites. Daylight-balanced and running off of AAA batteries, these lights are 45 watts each and can be attached to other LEDs to make a larger panel light. I love to use these diffused—by that I mean that I take a napkin or paper towel and tape it over the light to diffuse it.

Both of these lights can make the difference between me nailing a shot or missing it. For dancing shots, I have my assistant hold the light up and spotlight the dancers. This way, I have light to photograph and focus with. Without the lights, it would just be dark, whether I was using digital or film.

Video lights also help illuminate details at a wedding. I have used them to light the rings, the cake, table settings, and even the dress. Sometimes you just need more light, and video lights bring that for you. They also allow you to mold the light how you want it, because you can see its look on a subject in real time—unlike with flash, with which you won't see the lighting until you get your film back from the lab.

"Both of these lights can make the difference between me nailing a shot or missing it."

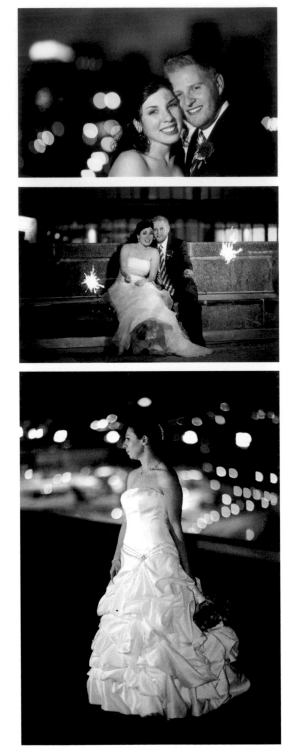

Images shot with LED lights.

Flash

Just because I use video lights, that doesn't mean I don't use flash. I have a love/hate relationship with flash. I love that it can light a scene for me, bring light to dark, and help fill in shadows and light group shots. I know it's a great tool, but I try to shoot without it as much as possible. I like dark, moody images, and flash can indeed light a photo, but it can also flatten it and make it boring. Flash can also let the viewer of the image become more aware of the camera in the photo. That said, I do use flash when I have to.

The simplest reason to use flash is when you need to add some clean fill light to a portrait. If I'm doing portraits in really dappled or shady lighting, and I want to get rid of under-eye shadows or just give more contrast to a dull scene, then I put on my flash—TTL at −1/3 stop—and shoot based on my handheld meter's exposure for the shadow areas on the person's face.

Portraits taken with direct flash.

Direct TTL flash on subjects moving toward the camera.

"I have a love/hate relationship with flash."

I also use flash on camera with the head 45 degrees over my shoulder and the power set to a manual setting based on the ceiling height, film speed, and aperture. I know that at 1600 speed, I can bounce my flash straight over my head with a Sto-Fen on it to bounce some light forward and be able to shoot at 1/3 at f/1.4 and capture a well-lit person two to three feet from me.

TTL comes in very handy when I'm shooting in a dark location and when the subjects are moving toward me. For example, when a bride and groom are being welcomed into a reception or are exiting a large church, I usually place the flash on TTL and shoot, knowing the D lens will transmit the distance of the bride and groom to the flash to obtain good exposure. I wouldn't have the time to calculate or to keep changing settings when action is happening like that, and TTL is my only and best option.

Note: Always test your flash with your gear before using it at a real event or shoot. Try it with all your gear to find out whether there are any compatibility issues, a sync problem, or a general error. Watch out for shutter sync problems and rear curtain sync issues.

Sync issues. I got these on half a roll of film when I decided to use flash off camera with PocketWizards and not my normal off-camera shoe cord. My F5 was set to rear curtain sync, so the signal to fire came too late, and the shutter didn't allow the flash to expose the entire image, hence the black or semi-dark areas on the bottom.

Traveling with Film Gear

As a film shooter, you need to be aware of how to travel with film and its associated gear. Never, *ever* check your film with your luggage. It will be ruined. No question. Pack all your gear into a carry-on bag. I use a bag called "airport security"; it's a single bag that fits all major airlines' carry-on size requirements, from little commuter shuttles to 747s.

I take two 35mm bodies, three lenses, and my flashes, as well as one Lomo camera and my Pentax 645. I pack all my film into a Ziploc bag. At the TSA checkpoint, I have all my film hand-checked. I don't let any of it get X-rayed. Supposedly films lower then ISO 800 will be fine, but I don't care—I don't want any of my film to get hit with radiation. This means I have to get to the airport with a little extra time so that TSA personnel can check my film. I then stow it back in my camera bag and load it in the overhead compartment on the plane when I board.

When I fly on planes that can't fit my camera bag as a carry on, I let them stow my gear at the gate, which means I pick it up at the gate and not at the baggage carousel. And I take the Ziploc bag with the film in it on board with me. I never let the film leave my side.

My camera bag and gear.

"Never, ever check your film with your luggage."

Staying Organized While Shooting

These bags will keep your film dry when you travel to different climates. Make sure to let your bagged film rolls get to the ambient area temperature before you open them or take out the film; otherwise, condensation could form and ruin your shots.

At a wedding, I shoot many films and treat them all differently. At any point during the wedding, I may have five to eight rolls of film in my pocket, some shot and some unshot. Some I'm pushing, others I'm cross-processing, and some just need to be processed via ECN2 process instead of the normal C41 color process. With all of this going on, it would be a total nightmare if I didn't keep track of what was what.

I use two tools to keep track of everything: a Sharpie marker and a Ziploc bag. As I shoot the rolls, I mark them with any special instructions—push/pull/cross/ECN2—and then toss them into a Ziploc. After the wedding, I sort everything and make a film sheet (see Table 9.1) listing what films are in the bag, how they were shot, and what I want the lab to do to them. I toss the list in the bag along with the film.

Traveling to foreign countries is different. I've traveled to Jamaica, Mexico, and Italy and have been able to get my film hand-checked, but on my last trip to Mexico, the security personnel would only hand-check *some* of my film—the rest had to go through the scanner. Everything turned out okay, but I made sure all the film above 1600 was hand-checked. Only the 400 and below film went through the scanner.

When traveling abroad, be sure you know the limits of what you can bring in for gear, or you may be fined or forced to have your gear held. In Mexico, I was allowed to bring two camera bodies, so that's what I did. It's no fun to get somewhere for a gig and then have all your gear taken. Trust me—I've heard plenty of horror stories.

Above all, be careful when traveling with your gear. There are thieves everywhere who would love to take your camera.

Table 9.1 Film Chart

Film	#35mm	#120 or 220
Portra 400	10	20
Portra 160	20	5
HP5 Plus 400	50	0
Delta 3200	3	5
Delta 100	2	2
Gold 400/Superia 400	50	0
Superia 200	5	0

Mark your film as you shoot it (or mark it *before* you shoot it) and then sort it after the wedding. Try to keep everything together, and you won't lose anything. Very little is scarier than trying to sleep after a wedding and wondering whether you lost a roll.

Assignments

In the following sections, Ingrid and I will talk about different shooting assignments and ideas to get you out there and shooting film. The more you shoot, the better you will become at it. Don't be afraid to do an assignment more than once; I'm sure you'll learn something new every time you repeat one.

Not only will these assignments help you see better, they will also allow you to try new film types and different cameras without the fear of goofing on an important shoot.

To judge your work, simply share it with others online and ask them what they think. If there's one thing that separates the online photography forums from those in the other arts, it's that people are brutally honest.

11

One-Roll Assignments

Many things make film unique compared to digital; one of film's more special attributes is that every shot really counts. For one thing, there are only 36 exposures on a typical roll of film. Digital cards can hold thousands of images, and digital images are often deleted if the photographer impulsively decides that the image on the LCD screen is no good. Think of how much history is lost at the hands of quick reaction. I can almost guarantee that some of my favorite images from childhood would have been deleted on digital because of a pair of closed eyes or a frown. Film doesn't allow this. The roll is intact—one image connected to the next in celluloid. I *love* this about film.

On that note…the one-roll assignments! What can you do with just one roll of film? What story can you tell when you're limited to 36 shots? How will you change the way you shoot, knowing you can't redo or delete when you click the shutter? You'll find a more thoughtful concentration and composition.

Try some of these projects:

◆ Shoot one roll of film over the course of 18 waking hours. Or shoot a day in the life. Or take a shot every 30 minutes. Try to force yourself to take the image right at that 30-minute mark. Open your eyes to what surrounds you at any given moment. Develop and print the roll and press the images into a little book. Simply write the date on the cover.

◆ Shoot one image on a single roll of film every day for 36 days. Pick a scene or an object and take a photo of it every day until you have used up your roll of film. Try to see the space or item differently each time. Shoot from different angles, at different times of day, and in different light. Scan your roll of film and see how the film works with different lighting conditions. This assignment will push your creativity, but it's also an informative test of your film in different situations when you have one constant. You can use this knowledge later for portraits, landscapes, and so on.

◆ Shoot one roll of self-portraits. You could do this with digital too, but it wouldn't be as much fun.

◆ Make your one roll into a photographic comic strip. Plan a 36-exposure story with cardboard bubbles and words. Print the film as a contact sheet.

◆ Make a photographic short story. Shoot one roll of film with the idea that you will only make a contact sheet of the negatives, and that will become your final print. Take photos of words or objects that tell a story. Or shoot a linear scene. You can write out a story beforehand and then take your time searching for words or symbols.

◆ Make a rainbow. Shoot six red-influenced images, six orange images, six yellow images, and so on until you have all six standard colors of the rainbow. Print them as a contact sheet or make prints and display them in a line or curved shape.

◆ Go monochrome. Do you like green? Focus on one color for an entire roll. See how that certain color shows up in unexpected places.

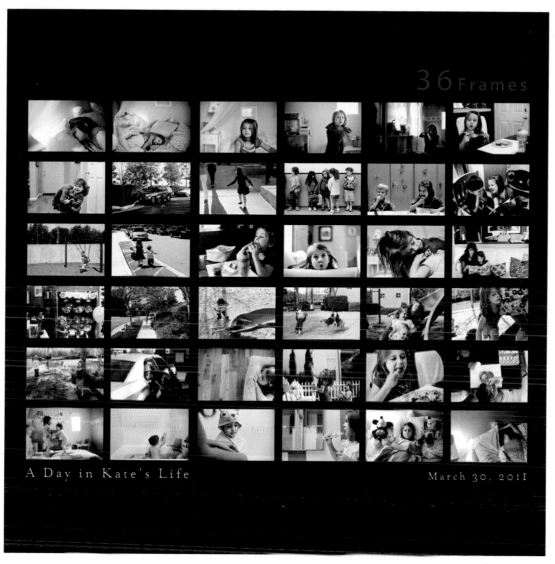

A day in the life. Photos by Paul F. Gero.

Go green!

So Many Choices!

With the huge variety of emulsions (films) available, be like a kid in a candy store. As creatures of habit, we tend to stick to the familiar. We find something we like, and we don't deviate. The following fun ideas will push you out of your comfort zone and encourage a bit of variety.

◆ Shoot from a mystery bag. Order one each of several types of film. Put the film in a brown bag and pull out a random selection. Shoot with that roll of film until you finish it. Then do it again until you've worked through the brown bag. Sometimes it's nice not to make the choice. You might be surprised by how different emulsions will make your daily life look completely different. You may find a new favorite.

Create a film grab bag!

◆ Surprise yourself. Have a friend cover a film canister's identity with a marker and load it into your camera. Most newer cameras set the ISO for you, or that can be the one bit of information your friend gives you. Shoot the roll, send it in, and be extra surprised when you get back your images.

◆ Take three. Choose three different films and run through each one exactly the same. This may work best if you have a controlled environment, but it doesn't have to be an exact science. You could shoot one object, subject, or landscape and simply compare the differences. This is just a good way to do a simple test.

◆ Do you like the grittiness of a grainy photo? You can make it happen on purpose. Try underexposing your film and then pushing it in development. Or try using some of the higher-ISO films. Expired film can sometimes be grainy as well. Printing your image a bit larger will also increase the visibility of grain in your image. 35mm film will show more grain when printed than a larger negative will. Play with grain and instantly make your photos a little more rock 'n' roll.

Go gritty with grain.

Play with Friends

Remember that telephone game you played as a kid? The one where you whispered into the ear of the person next to you, and the story had to make its way around the circle? The story was never the same as when it started. Have fun and try some variations on that theme.

◆ Pass the camera around to a select group of friends with a simple set of directions or one word that everyone must interpret in his own way. There's no scrolling back to see what was shot before. There's no way to be influenced by others' images. At the end of the game, you should have an interesting collection of images on the same theme. Divide the number of shots by the number of players.

◆ Create an instant story. Use a Polaroid or Fuji Instax camera to write a little story with your friends. Have the first person take a photo, and then have the next person draw off that image. Have the third person draw off the first two images, and so forth until you have 20 shots. There should be no words or communication other than the photos. You could rotate through the same five or so people if you can't find 20 to participate. Hang the images on a wire using small clips.

Go Lomo

Plastic cameras are everywhere now. You can pick them up online or at the mall. I make a habit of carrying my Diana Mini with me everywhere I go and trying to shoot one or two frames a day with it. One way to get into film without worrying too much about the technical aspects is to buy a toy camera and just have fun. Don't think, just shoot. It's lightweight and very small. Stick in a roll of Portra 400, and you're good to go in most lighting situations. One great thing about shooting color negative film is the great latitude. Most plastic "toy" cameras are made to shoot 100-speed film in bright sun. The wonderful thing about Kodak Portra 400 is that it will hold highlight detail even when it's overexposed by several stops. I've found that by toggling between the sun and shade settings that most of these cameras have (as well as bulb for longer exposures), you can shoot with these little cameras everywhere. You can experiment with many different films, of course—punchy and high-contrast ones seem to be popular with many Lomo users.

◆ Shoot up or down. Set your camera to the farthest focus point (if the camera has that option) and instead of taking photos looking out, point toward the sky. Trees, clouds, buildings—run a whole roll with one particular point of view. Adjust the focus and do the same pointing toward the ground. See how Lomography can make the everyday a little different, a little dreamlike. Mix different films in your rotation to find what you like best.

Point your Lomo at the ground and at the sky.

◆ Shoot while shotgun. Keep your little plastic camera in the car. Take photos when you're in the passenger seat—through the car window or with the window rolled down. The camera is so lightweight that you can hold it out the window and snap.

Double Expose

Double exposing color negative film can be fun and easy. And because of the film's wide latitude, you'll still retain highlight details when you over-expose. Almost all cameras allow you to expose the same frame more than once. On non-electronic cameras, there is usually a lever that allows you to not advance the film. On electronic cameras, such as my F5, there is an option in the menu that allows me to keep taking photos without advancing to the next frame. Here are a couple fun assignments you could do:

◆ Expose a face, close up in flat light, and then, without advancing the film, take another frame overtop of the first one. Use a texture such as brick, cement, or a hedge.

◆ Photograph someone walking across a field. Use a tripod to keep the background the same and have your subject move across the film plane. You'll need multiple exposures here. Every time your subject takes a few steps, take another frame without advancing the film. This way, it will look as if there are four or five of your subject walking in a line, while the background will be the same.

◆ Do a whole series of double exposures. No rules other than that. Make 10 shots, hang the show in your hallway, and invite friends over to see it.

◆ Don't advance your film all the way; let the images overlap in some neat panoramas.

Create some fun panoramas by letting images overlap.

Expired Film

You can sometimes buy expired film at old drugstores or online, or maybe you have some random rolls tucked away in a drawer someplace. Or, do a quick Google search for expired film, and you will come up with many links to buy long expired and recently expired film. Some of the film will be out of production, and some will be film that just went past its expiration date. In terms of spoiling, film does not really go bad that quickly. Besides, when film is expired, it's not unusable—it's just not stable in terms of holding the characteristics that the manufacturer intended it to hold. This could be in contrast, latitude, grain, or color. Characteristics will change as film gets older.

Expired film can be unpredictable, and that's what makes it so much fun. For this assignment, I want you to get some expired film. Don't get really old stuff—try to stay within the last decade. Then shoot it, bracket your exposure, and try to overexpose. Most film will lose its sensitivity to light as it ages, so a 100-speed film might be a 50 now—but again, this all depends on the film and how it was stored. I have shot 10-year-old Fuji Velvia 50 that was kept in a freezer in Ziploc bags, and when it was thawed, it was good as new. I shot it at 50 and 25, and everything was great.

You might even use your roll of expired film to photograph something very modern. Make a still life or photograph some modern architecture. The contrast alone will make a statement.

These are images taken on expired Fuji Sensia 200 film. Notice the increased contrast and grain.

Storing Film

Film should be kept refrigerated and away from heat and humidity to keep it fresh. Film that is not kept well can become grainy and fogged. If you don't plan to use film for a long time, you can freeze it—just make sure it's in a Ziploc bag to prevent moisture from getting to it.

A Day at the Beach

Sun, sand, and water! One of my favorite places to be in the summer is the beach. I love it. The beach is filled with many colors, events, people, and objects to photograph. In my photos, I like to share the feelings of fun at the beach. Everyone is usually smiling and happy, and I love that.

I love the color at the beach, so I like to shoot on high-saturation films, such as Ektar 100, to convey the blue skies and the colors on everyone's bathing suits. I recommend shooting with low-speed film,

because there is plenty of light at the beach—the sand and water both bounce light everywhere.

For gear, I like to bring my Horizon Perfekt to get panoramas and show the vast beach vistas. It's a great camera for shooting other beachgoers, too, because they don't see the camera as a camera, and they don't react as if they are being photographed. It's also fantastic for getting different perspectives at the beach.

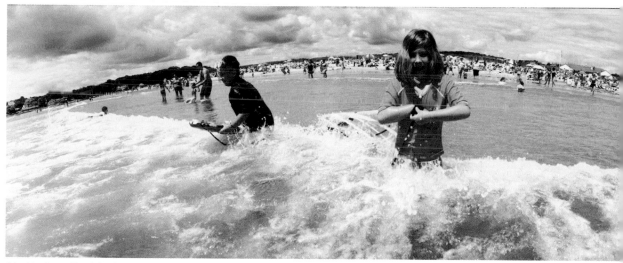

My Horizon Perfekt is, well, perfect for beach vistas.

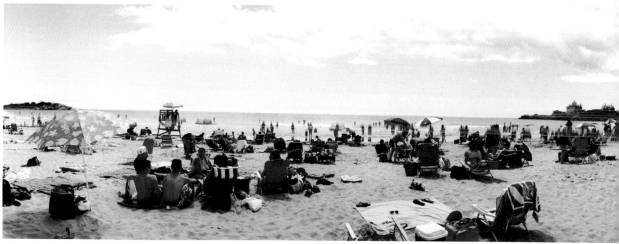

I don't like shooting medium format at the beach, because the cameras are pretty big and aren't that weather-tight. There is sand and salt everywhere, so even if you're shooting with 35mm, make sure to keep your gear clean and be super careful if you change a lens. A little sand in your camera will leave you with a host of problems.

Another fun thing to try at the beach is to shoot with a long lens rather than a wide lens. A long lens will compress everything and make a crowded beach much more interesting.

Stay at the beach for the day and photograph the light as it changes. Beaches look awesome and completely different at different times of day. From clear sunrise at dawn to beautiful sunsets and glowing skies, the beach is full of material for you to use in your photographs.

You can also try to photograph only details at the beach. Look for shells, starfish, and driftwood. The ocean tosses all sorts of things up on the shore; just go for a walk and see what you can find.

Every time you go to the beach, try to photograph something new. Now get to it!

Photograph all the action on the beach.

Fishing Port

Photographing people and what they do gives me great joy. I think photojournalistic-style portraits of people best capture who they are and what their lives are like.

If you live near the shore, a fun assignment is to shoot fishermen going about their day. Go to the local fishing port and see whether you can photograph the men and women who bring us our daily fresh fish. Fishermen are hardworking people with gritty jobs. It's not a pretty job, but because it's so messy, it provides a lot of photography fodder.

Be mindful of the people you're shooting—always ask whether you can take their portrait. Most people will say yes, and if they don't, you can just move on to another boat. If people allow you to photograph them, be thankful and polite.

I like to use a good portrait lens and one wide-angle lens when I photograph people in their working environment. I don't want to be obtrusive, so a quality 50mm or 85mm lens gets me good distance for my shots. Use the wide angle to get some shots establishing the scene. Tell a story.

Try to look for the shots that tell the story. No single photo will perfectly describe a person, so look around, take in everything, and then take the shots. If I had only photographed the captain, you wouldn't have an idea of the scale of the life at a shrimp port, so I photographed everything—from the dock with the birds, to the boats, to the crew, to the man inside shelling the shrimp before freezing them.

Images from a shrimp-boat port in South Carolina. I was exploring this little fishing port with a friend of mine when we saw this crew sewing their net together. They agreed to let me come on board to take some portraits. I promised I would send them copies of the images in return. I shot them using my Nikon F3 with a 28mm lens and an F5 with an 85mm lens. I used Fuji Reala 100 and Superia 400 for all these photos.

Flowers

I'm the first person to say that I'm no expert on photographing flowers—but that would never stop me from shooting them. Photographing flowers is an art in and of itself. I just know that when I see a lovely plant, I like to take a photo.

Making flowers look good comes down to a few simple things: light, contrast, and gear. I recommend using a macro lens that will allow you to get close to the flower and fill the frame. I find that flowers look best with some dew on them, just after it rains or in the early morning, when dew from the night is still clinging to them. This isn't always the case, of course. Flowers can look good in a vase, too—it's up to you to photograph what you like.

Here are a few key tips:

- ◆ Pay attention to the background. You want your flower to stand out and not get lost.
- ◆ Watch for patterns and look for the angle that will focus the viewer's attention on the flower(s).
- ◆ Don't be afraid to use flash; it can make flowers pop.
- ◆ Sometimes pulling back from the flower and taking in a big scene is better than just shooting a close-up.
- ◆ Use a slow-speed film so that you can pick up as much detail as possible.

Macro shots of flowers are great, but try shooting some wider angles, too.

Fourth of July

One of my favorite holidays is America's birthday. It's a day celebrated in virtually every town across the United States. Parades, parties, and barbecues abound, and the day ends with fireworks and music. There is plenty to photograph.

For this assignment, I challenge you to photograph local celebrations. Whether it's a parade, a carnival, or a firework extravaganza, you'll have the opportunity to document the day.

I recommend using a 35mm body with a good zoom or two prime lenses, one wide and one tight. Walk your streets, stake out the good spots, and watch for shots. Look for smiles and people having fun, and take photos. Your best bets for action and changing lighting situations are 200- and 400-speed film. For fireworks, you'll need a good tripod and a shutter release. Place the camera on the tripod and set the Exposure mode to Bulb. You can use a shutter release cord to trip the shutter. You don't want to trip it directly because you could inadvertently cause camera shake. Use a 400-speed film and vary your shutter speed to record some good fireworks.

Fourth of July photos from Marblehead, Massachusetts. I just walked around town and took photos of what I saw happening. I had only my Horizon Perfekt with me, because I was on a boat that day and wanted to keep my gear to a bare minimum.

Concert

You can only learn to shoot in bad lighting one way: Shoot in bad lighting. For this assignment, find out where the local indie bands play and buy a ticket. Take some 400- or 800-speed film and be ready to push it to 1600 or 3200. Try some BW 3200, too. Learning to spot meter and shoot a band in a crazy lighting scenario will help you learn more about how to expose in low light and freeze action.

Spot meter for band members' faces—that's usually the best light—and then spot meter for the key lights. Find the average and shoot. Be careful with matrix or average metering modes in these situations, because all the crazy set lights and super-dark areas can wreak havoc with a camera meter. It's best to spot meter and then guestimate and shoot.

Images of a band playing in Cambridge, Massachusetts. I shot this concert with Portra 400 rated at 1600 and then had the lab push the film two stops in development. I shot mostly wide open at f/1.4 or f/1.2 and then varied my shutter speed as needed. It was mostly set to about 1/60 to 1/125.

Commercial Portraits

For this assignment, I don't want you to photograph a model, but rather a real person with a business. This means that you take professional photos for someone, which they can then use for their company. Just like when you're shooting models, lighting is a key factor in this type of portrait, next to posing.

With commercial portraits, you need to be much more aware of your location and what the photos say about your subject. A person's image is very important, and your picture has to convey that image to viewers.

Use a good 35mm lens to give a sense of your subject's world. This is not a fashion shoot or a headshot, so you don't want to use a tight lens that's going to throw the background into blur.

Use off-camera flash and studio strobes. I take a white sheet with me to make a softbox on location. I simply take two light stands and then tie the sheet between the two. Then I place a flash directly behind the sheet, aimed straight at it. I then have an 8' × 10' softbox that only cost the price of a bed sheet.

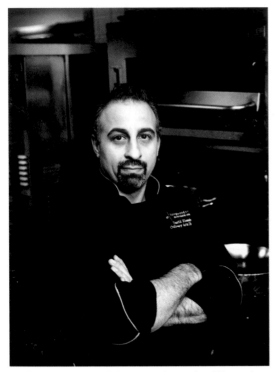

Chef David in his kitchen. I used a 35mm lens and 400-speed film rated at 250 and processed normally. I had three lights set up, one bed-sheet softbox, a strobe bounced to the ceiling, and an on-camera flash bounced on the wall behind me. I balanced everything using my light meter.

For these outdoor portraits of the chef, I used my Pentax 645 with a 75mm lens and Portra 400 rated at 200. There was no additional lighting, just good old afternoon light.

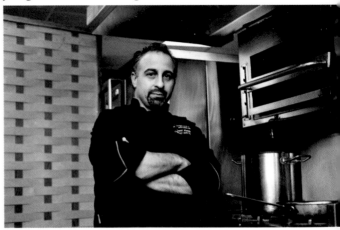

Couples Portraits

For this assignment, I want you to photograph some couples. Photographing a couple to show that they are together and in love can be fun and exciting. You will learn to create great portraits of people in love.

You can pose the couple or photograph them like a photojournalist—or even like a fashion photographer. It's up to you.

For me, engagement photos are portrait sessions. They aren't about getting a photo for a newspaper; they're about taking real shots of a real couple, not cookie-cutter posed shots.

For most couples, I like to use my Pentax 645 and shoot in the afternoon light. I talk to the couple, get to know them, and learn who they are and what they're about before I start taking photos. In a sense, I'm interviewing them. Knowing someone is very important when you're photographing

them. You want them to feel as if they know you too—that you're not a total stranger. You might be surprised by how much comfort levels can impact a portrait session.

I like to keep my photos of couples simple. I find sweet light, take a reading with my light meter for the film I'm using (I meter differently for different films—see Chapter 3 to see how I meter for each), and then describe what I want the couple to do while I shoot. I usually start by having couples hold hands and walk or look at each other. What they do after that is up to them.

I also like to get a couple of cool headshots—a shot that is all about the person as an individual, not as a couple. A close-up shot of someone can tell you a lot about them. You can really look into their eyes.

I love these shots, taken on my Pentax 645 with Portra 160.

Babies and Kids

Odds are that you know someone who has kids, who just had a baby, or who will be having a child soon. Kids are everywhere, and they make great subjects as infants and even more challenging subjects as they grow up. Older kids like to run around and goof off. They don't want to sit for portraits—well, most don't.

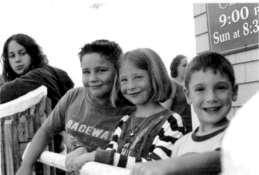

You can get some fun, goofy pictures of kids being kids.

Newborns

Shooting newborns isn't as challenging as it might sound. They actually don't move around much and are generally fairly easy to pose. I like to keep it simple when shooting newborns and very young babies. I try to find a clean background and lay the child down or prop him up against something. (Obviously, you must make sure the baby is in a safe place with his head fully supported at all times!) Medium format is great for really young babies who don't move much; it allows you to get much more detailed shots of the child.

I like to use natural light as much as possible when shooting babies. I don't want my baby photos to look like a fashion shoot—I want them to be very documentary-based. Of course, you certainly don't have to do it my way! If you want to light up babies with multiple strobes and make a high-end studio-type shot, that's awesome—it's just not my style.

An extra hint for you: Macro lenses can be very useful when shooting newborns if you want to get detailed shots of their little body parts or fill the frame with the baby's head

When babies are slightly older and home from the hospital, you can have a bit of fun with them. I started shooting these twins in their parents' room with just a blanket under them. Then we moved outside, and I got the family to hold them up and have fun. I metered for the shadows and shot with Kodak Portra 160. Use a slow-speed film to get as much detail with 35mm as possible.

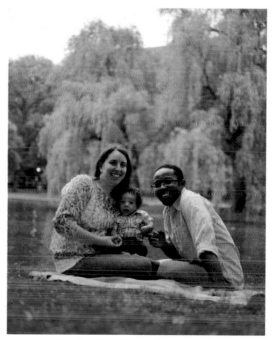

I shot this newborn's pictures on my Pentax 645 with Tri-X 100 rated at 1600. Black-and-white film works well with infants. I prefer it over color because newborns tend to have rashes and reddish skin. Black-and-white film makes their skin look clean and clear.

For a family shoot in the park, I brought my Pentax 645 to get neutral shots of the parents holding their newborn. We shot for under an hour and just walked around the park looking for good light. I shot about 40 frames with Portra 400 and was very happy with the results.

Older Children

When kids are a bit older, you can have a little more fun with them. I enjoy shooting families with young children. When kids reach about eight or ten years old, they actually enjoy being photographed, and it can make for a fun shoot. This is the age right before they turn into teenagers and become very self-conscious.

For a family shoot like this, I like to use all my gear: panoramic to 645 to normal 35mm. Each camera can help you capture something different.

Try to be aware of what the kids are doing, and never be scared of them. If you're nervous, they will see right through you, and your shoot will be over. Be happy and cheerful with kids—keep them engaged and work with the parents to make everyone feel great. I don't tell people to smile; I tell them to tell a joke or to tickle each other. I want to provoke a real emotion so that I get real smiles and joy. Try it.

A word to the wise: Autofocus comes in very handy when you have kids running around.

For locations, think simple. This isn't an edgy fashion shoot, so that gritty alley or a junkyard may not be the best place for little kids. Think about safety and find a place that will work well with the family you're shooting. Talk to them and find out what they like to do and where they like to go with their kids.

These photos were taken with me having all my gear handy. I like to take a travel bag with me to my shoots so that I always have what I need on hand.

Dogs!

I love animals—I'm crazy about them. I wish I could go on an African safari and see all kinds of animals, but alas I live in Boston, and aside from deer in the forest, the animals I have the greatest access to are dogs.

This is a good thing, though. Dogs are usually friendly and not shy, like wild animals can be. You can actually do photo shoots with dogs—dress them up or just let them run around. Most dogs love people.

For this assignment, your goal is to photograph a dog. You can photograph it just lounging, or you can pose it. I like to bring my dogs into the yard, get really close to them with a wide-angle lens, and shoot them close-up. Dogs move fast, but you don't need autofocus if you can get them to sit down.

If you're not photographing your own pet, have fun and play with the dog before you start taking photos—let him get to know you. A happy dog is much easier to photograph than an angry or suspicious dog.

Here's a good tip: Fast film and some dog treats can be lifesavers when you're trying to shoot dogs. Also, for darker dogs, use fill flash to highlight their hair and features; otherwise, you'll lose the detail.

I took most of these shots of dogs in my own yard.

Cities: Part I

New York City at night, taken with BW film on my XPan.

Some of my favorite photos have come from just walking around and exploring a city. I live in Boston—a rather typical city with good parts, bad parts, trendy areas, and all the normal things you expect to find in a big city. I like to just drive out somewhere, park my car, and walk around to look for new things and people—anything cool.

When I travel for gigs or conventions, I try to save at least one day for myself so I can go out and explore. It's thrilling for me to just pop around a corner onto a new street, to a place I've never been before.

For this assignment I want you to find a city close to you and go explore it. Photograph the city as you see it. Tell the story of the city you see. Try shooting the city in BW and see how the shapes of the buildings and the streets create their own images. Shoot at night with a tripod or with high-speed film and let the colors of a bustling square or intersection fill your lens. Cities don't sleep—they just go into neon and tungsten lighting, trading off from the sun.

When exploring, it's helpful to travel light, because you will likely be walking around a lot. You also don't want to be a target for theft. I recommend taking just one body and a good lens or two. You don't want to be burdened by the weight of a heavy camera setup. Bring a fast lens if you're shooting at night, or carry a mini tripod. Try experimenting with slow shutter speeds.

When photographing people in the city, try not to attract a lot of attention. People can get cautious and angry. I like to walk fast, and if I see something I like, I shoot it and then keep moving.

Images of New York City and Boston.

Cities: Part II

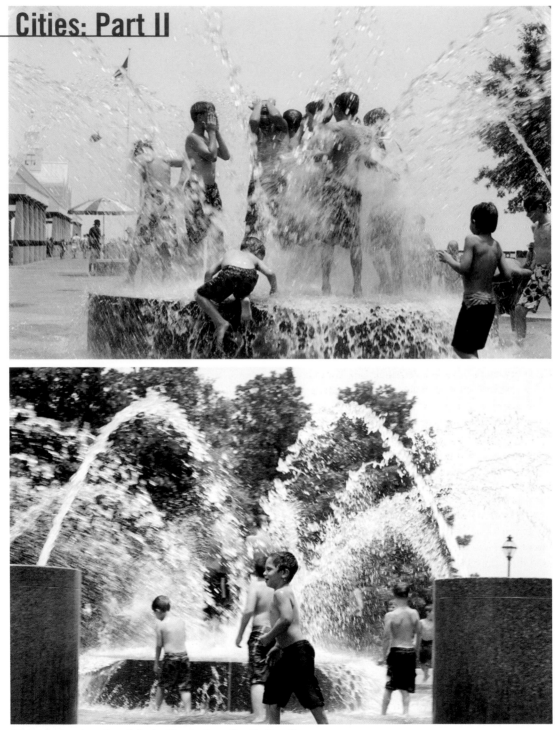

Kids playing in a fountain in Charleston, South Carolina.

Shots from my walk around Charleston. I shot with my Pentax 645 loaded with Portra 160 and with my Nikon F5 with Reala 100.

Not every city is huge, like Boston or New York City. Many are more rural or smaller. Some are older and more charming, but regardless, every city has a story. If you don't live near a large city, then go to the largest town or city near you to photograph. I promise you'll be able to find subjects, objects, and scenes to photograph while you explore.

On a recent trip to Charleston, South Carolina, I walked around the downtown streets to the ocean and even stopped at a barbecue house. Everywhere I went, I took photos. While shooting in the city, I used the Sunny 16 rule and checked them with my camera's meter. (For a discussion of Sunny 16 rules, see the next section.) It was midday, so I used 100-speed film and metered for the shadows. I just shot and shot.

Look for shapes, signs, color, and contrast that appeal to you. Try shooting the buildings with a telephoto lens (or one that isn't a wide angle) to compress the buildings. Then try with a wide-angle lens so you can see the difference when you develop your pictures.

Sunny 16

For this assignment, I want you to shoot without a camera meter. Get a fully manual camera that has no meter or batteries and shoot a roll. The following information will teach you how to shoot without a camera meter.

I want you to be able to shoot without a light meter in your camera or a handheld meter in your pocket. Learning to set exposure based on just looking at the light where you're shooting can save you time and create better photos for you. You can trick camera meters, but knowing ahead of time the general exposure for where you're shooting can tell you how to compensate for your camera's built-in meter.

The Sunny 16 rule is simple. Set your shutter speed closest to the ISO of your film that you have loaded. So, if you have 400-speed film, you would set your camera to 1/400 or 1/500—whichever setting your camera has.

Now, here's what changes: your aperture. The shutter speed stays the same while you compensate for the light. Here are some guidelines:

◆ For bright, direct sunshine, use f/16 or f/22.

◆ For a partly sunny or a bright, overcast day, use f/11 or f/8.

◆ For the open-shade side of f/16 light, use f/8.

◆ For a cloudy day, use f/5.6.

◆ For dark shade, use f/4.

So now that you know the rules, get out there and shoot a roll to see how you do without a meter. Camera meters can be easily fooled, but once you teach your brain how to expose, you will know when to trust and when to ignore your camera's meter.

DAYLIGHT EXPOSURE GUIDE
Shutter speed at 1/250 sec.

Seashore or Snow Scenes under Bright Sun	Bright Sunlight	Hazy Sunlight	Cloudy Bright	Cloudy Day or Open Shade
f/16	f/11	f/8	f/5.6	f/4

Follow Sunny 16 rules.

Super 8mm

This assignment is meant to open your eyes to the larger world of film. Film is not just for stills; it's for movies, too. When you go to the movies, there's a good chance that what you're watching was shot on film, not digital.

All the qualities that film yields for stills apply to movies, too: better highlight and shadow details, smoother skin tones and color renditions, and film-imperfection qualities.

For this assignment, you'll need a super 8mm film camera. I recommend going to eBay and getting a cheap one. I have two great Canon cameras—the 310XL with an f/1.0 zoom lens and the 512XL with an f/1.4 zoom lens. These cameras are fully automatic; all you do is focus your lens and pull the trigger that starts the film moving at 18 fps (frames per second) and opens the shutter. The aperture is all automatic. You can get pro-level super 8mm cameras with full manual control, but for this assignment, you don't need that.

Next you'll need some film. Kodak has some amazing film available for super 8mm, from Vision 3 200T and 500T, to BW and 100D. I recommend getting some 200T, some Tri-X BW, and 500T for low-light filming. All you have to do is load the film into the camera, set the camera for daylight or tungsten shooting, and shoot. Because the films are tungsten-based (white balanced for incandescent light), when you shoot in daylight, the camera has an 85B filter that it will use to color-correct the blue daylight to the 3200K tungsten film. This is accomplished by a simple switch on the camera's side. There is a picture of a sun and one of a light bulb. When you're shooting inside with artificial light, you keep the switch on the light bulb, and the filter is off. If you go outside into the daylight, you set the switch to the sun, which will activate the 85B filter in the camera and correct for white balance.

A collection of super 8mm stills.

Now you just have to go out and shoot. Shooting super 8mm can be fun and challenging. Learning to shoot movies—even home movies—comes with a learning curve for still shooters who are used to recomposing and looking for a new shot every few seconds. With movies, you need to hold the camera steady and keep the shot going for some time. Panning back and forth, zooming, and changing the viewpoint all the time will make for a dizzying movie.

Shoot from your eye level. Shooting super 8mm is not like shooting a 35mm motion picture. It's fast, grainy, and very personal. The small camera will allow you to get close to people and capture moments that would otherwise be disturbed by a larger camera setup. Above all, have fun! Super 8mm isn't meant to be perfect; it's meant to be fun and close to your heart.

After you've shot your film, send it to a movie lab near you and have it telecined (transferred frame by frame to video, QuickTime, and/or AVI) to

HD. I use Cine Lab in Massachusetts. Pro8mm in California does a great job, too. You can also contact Kodak to find the closest lab to you.

After you have all your footage back in a .mov format, you can edit it on your computer using a simple program such as iMovie, or you can use pro software, such as Final Cut Pro or Adobe Premiere.

Post your finished film on YouTube or Vimeo. I personally use Vimeo because I like the quality and look of the site. When you're making a film ready for the Web, use H.264 compression and use the highest bit rate possible to ensure the best HD file. You don't want to lose quality due to file compression. So experiment and look at the upload limits for the site you're going to use. I always try to stay above 15000 kilobits per second.

Time of Day

As the light changes from hour to hour, so does the way we see the world. Purple and blue dawn gives way to clear blue skies, which later yield red and orange sunsets. The color of the world around us is most magical in the early morning and in that last hour of light before night falls.

For this assignment, I want you to go out and shoot a location or a person at different times of the day with the same film, so that you can see how the color and direction of the sun's light can affect your photos.

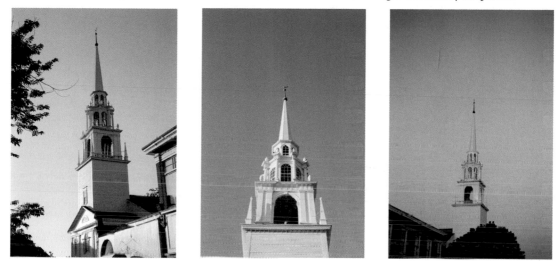

I photographed this church with Fuji 100-speed film in afternoon light, when the sun was still pretty high, and then again at sunset. Look at the difference in the contrast and color. The first shot features high contrast and a bold blue sky behind the church. The second image is flatter, warmer, and more romantic.

As I drove home from walking around a little coastal town, I saw a beautiful river. I pulled over, climbed up onto a guardrail, and started shooting. I knew the light was fading fast, but I wanted this shot. I bracketed my exposures and shot quickly. (I also shot quickly because the flies were eating me alive, so make sure you have proper bug spray if you want to shoot a marsh!)

Sunset at the marsh. Notice how the image is darker as the sun sets? Which one is your favorite?

Instant Photography

This is a fun assignment, but not everyone will be able to do it. For this assignment, you'll need an instant camera, such as a Polaroid or a Fuji Instax, or a Polaroid back for your camera. You'll also need instant film. It's still around and pretty easy to get, but it's not the cheapest stuff on earth.

If you have a Polaroid SX-70 or 600 series camera, you'll need to get some Impossible film from the Impossible Project. Their film is great but not yet perfected. Each of their films is a little quirky, so make sure you read about them on the Impossible Project site so you can use them as they should be.

If you have a Polaroid land camera (land cameras were popular Polaroid cameras made for decades—they are easily found on eBay or at camera shows) or a film-pack back for your medium format camera, then you can shoot awesome sheet film made by Fuji. They offer color and BW in 3000 ISO and 100 color. This film is awesome because not only do you get the instant image, but you also get a negative that you can dry and scan to make more prints from later. With this film, you take a photo, pull out the film, and then wait the designated time for the image to develop. Then you peel apart the negative from the photo, and presto—instant photo! The time you have to wait for the image to develop is determined by the film you are using as well as the temperature.

Your other option is a new Fuji Instax camera. These cameras come in many shapes and sizes and produce both large instant prints and little credit card–sized prints. They are point-and-shoot, you don't have to do any work with the film other than loading it. The camera and film do everything, so you don't have to worry about exposing

Various instant-film images I have shot and scanned.

the film to light when it comes out or having to count the seconds until you can peel apart the image and see a photo. It's instant.

With that, I want you to go out there and take instant photos! Share them with your friends or the people you photograph. See how cool it is to actually have an instant print that you can show people. Trust me—you're gonna like it!

A Snowy Day

If you're like me, you don't live in the sunshine land, where it's blue skies and warm weather year round. Here in Boston, we have winter for almost half the year and snow from November to March. Lots and lots of snow—not fun. The bright world full of color turns white. Gray clouds cover the sky, and most hope is lost—okay, it's not *that* bad. The snow can be very beautiful and fun. It transforms landscapes into magical and awesome places.

Even if you live in sunny California, though, you may have access to snow. And if you do, this is a good lesson for you. Shooting a snow-covered landscape can be tricky at first. You need to watch out for glare from the sun, and you must make sure your exposure is correct. If you're using your camera's internal meter, it will want to make the white snow gray, so you need to overexpose or take a handheld reading with a light meter to get the correct exposure. A handheld meter does not take a reflective reading, so the snow won't affect it. I just hold it up in the direction I want to shoot and take a reading or two.

Try to shoot just after it snows, when the trees are still covered in fresh powder and before the sun has had a chance to come out and melt it.

My car surrounded by snow mounds from winter storms. I was walking back to my car and realized I had to get a shot of the size of these piles. I had my Canonet QL17 with me, so I fired off a few frames and then got back to my heated seats.

These images are from a day spent skiing in New Hampshire. I took my Horizon Perfekt with me to try to get some really cool vista shots from the top of the mountain. When I saw the snow-covered trees, I was in photo heaven and just wished it wasn't four degrees out and that I had more gear with me.

Festivals

All around the world, there are cultural and national festivals. I am an Italian living in Boston—a first-generation American—and we hold a giant feast in Boston's North End. These feasts are celebrations of religion, culture, food, music, and love. People march around with bands, carrying statues of patron saints and collecting donations. It's a very emotional event when you see your entire family there—grandparents to grandchildren, who have all taken part in the feast throughout the years, from the old country to the new.

For this assignment, I want you to capture a cultural or national event. Show the people and the festivities. This is photojournalism, so capture the event and tell a story. You will have to think and act quickly. I usually don't want people to know I'm photographing them if I'm trying to be photojournalistic. Generally speaking, you don't need permission to take photos in pubic areas and publish them, but if you're going to take a portrait of someone and sell it or use it commercially, then you do need permission from the person.

For these photos, I used my Canonet QL17 loaded with BW 1600 film. I wanted to be invisible—well, I wanted the *camera* to be invisible. My family has been members of the Madonna Della Cava society for generations, so I was able to get close to the action. Even so, I didn't want to be like a tourist with a big SLR, snapping photos of this sacred event. I wanted to be part of it and record it. My little Canonet let me do that. It's small, and no one even knew I was shooting.

I recommend using a small 35mm camera for this assignment. A rangefinder would be best, but an SLR will work too, as long as you're quiet.

The feast of the Madonna Della Cava (the Madonna of the Cave), all taken with HP5 Plus 400 pushed to 1600 with my Canonet QL17.

Projection Shoot

For this shoot, you will need a model and a projector. This is kind of like taking a double exposure, but captured at the same time. You will be photographing two images overlapping at the same time. It's a cool way to get something very different and very sexy at the same time.

All you need to do is project an image of some previous photograph onto a wall and then have your model stand in the path of the projection. You will need to do this in a fairly dark room so that the projector is your main light source. You will get a shadow the farther she is from the wall, and the image will be wrapped around her. If she leans on the wall, the image will be in perfect focus, wrapped onto her with no shadow behind her.

Play with different images and poses. Use a light meter to get a good reading. Expose for the projected image on some frames and for the model on others.

Shot with Fujicolor Press 800. I rated the film at 500 and developed normally. The film was actually about a year expired, but I was very happy with the results.

12 The End?

In closing, I hope that you have been able not only to have fun, but also to become a better photographer. I know I'm still learning every day, and I've learned more myself by just writing this book. I hope you have left this book more knowledgeable about the film-photography world and ready to tackle any subject matter with more options than just a dSLR. Your mind should now be open and ready to see things in new ways, so you can try different options and utilize all possible tools. You should be limitless....

NO FEAR

Don't be afraid to shoot film. Yes, there's no LCD to see what you just shot, but trust me—you'll live.

Have fun and get shooting!

Film and Camera Resources

I highly recommend the following labs for developing, scanning, and printing your film:

- ◆ The Finer Image: Massachusetts
- ◆ Richard Photo Lab: California
- ◆ North Coast Photographic Services: California
- ◆ Hunt's Photo & Video
- ◆ Indie Pro Lab: www.indiefilmlab.com
- ◆ Color Services: California
- ◆ Photoworks: California

I recommend the following for buying film:

- ◆ Hunt's Photo & Video
- ◆ B&H Photo Video
- ◆ Adorama
- ◆ Unique Photo
- ◆ eCameraFilms.com

I recommend the following for buying film cameras:

- ◆ KEH
- ◆ Hunt's Photo & Video

Index

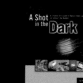

Like the Book?

Let us know on Facebook or Twitter!

facebook.com/courseptr

twitter.com/courseptr